IMAGES
of America

HAWAI'I TSUNAMIS

ON THE COVER: It was about 7:00 a.m. on April 1, 1946. People were reporting for work in downtown Hilo, Hawaiʻi, in an area where the bus terminal is today on Ponahawai Street. The ocean had receded all the way out to the breakwater before this massive 35-foot third wave in the series came smashing in. A barber had just gotten a new camera and was taking photographs around town. As he captured this image, the man on the right exclaimed that they needed to get to high ground. This unforgettable moment frozen in time reminds us not to forget; we need to remember and honor those lost in previous tsunami events and be mindful, educated, and aware of the dangers that tsunami events pose. An ever-present threat in Hawaiʻi, it is not a matter of if, but when another destructive tsunami will occur. (Cecilio Licos Collection.)

IMAGES
of America

HAWAI'I TSUNAMIS

Barbara Muffler
and the Pacific Tsunami Museum

ARCADIA
PUBLISHING

Published by Arcadia Publishing
Charleston, South Carolina

Printed in the United States of America

Library of Congress Control Number: 2014948826

For all general information, please contact Arcadia Publishing:
Telephone 843-853-2070
Fax 843-853-0044
E-mail sales@arcadiapublishing.com
For customer service and orders:
Toll-Free 1-888-313-2665

Visit us on the Internet at www.arcadiapublishing.com

This book is dedicated to the men, women, and children who have lost their lives in previous tsunami events. By honoring the past, we are better able to embrace the present and make thoughtful decisions in the future.

CONTENTS

ACKNOWLEDGMENTS

First and foremost, I would like to acknowledge the tsunami survivors who have provided their stories to the Pacific Tsunami Museum, stories that have been an invaluable tool to teach others about tsunamis. People learn through the stories of others and through oral tradition. These stories have been used in museum exhibits, publications, and educational group talks. When I give a talk and say, "Now I'd like to tell you some stories," I have the attention of every person in the room. I would also like to acknowledge former museum executive director Donna Saiki, who abridged many stories for the museum's annual tsunami story festival event, stories that I abridged further here. Additionally, Donna gave me the original inspiration to write this book; through the years, I learned so much from her about Hilo and Hilo's tsunami survivors. While Donna originally inspired the book, the museum's current executive director, Marlene Murray, has made the book possible by giving me the opportunity and encouragement to write it, enabling me to carve out the many hours needed.

I would also like to acknowledge the Pacific Tsunami Museum (PTM) board for their confidence in me to write on behalf of the museum. Others who helped me include John Smith, PhD, science director for the Hawai'i Undersea Research Laboratory (HURL), who provided landslide references and bathymetric maps of Loihi, and Rachel Orange, HURL's data manager, who provided permission to use Loihi images taken by Dr. Alexander Malahoff. Two notable collections that were donated to the museum recently have played a huge role in this book. James Kerschner's US Naval Air Station collection contains incredible aerial photographs taken after the 1946 tsunami, and the Charles Hansen collection contains color images taken after the 1960 tsunami. Charles went out of his way to provide images for the book at the last minute. I would like to acknowledge Dan Walker, PhD, for granting permission for use of the "Time Travel Map" that shows how many hours it takes for tsunami waves to reach Hawaiian shores from their point of origin. Many thanks to Watermark Publishing for permitting use of the reference map of pre-1946 Hilo from their publication *Exploring Historic Hilo* by Leslie Lang. Finally, a big thank-you to Walter Dudley, PhD and chairman of the museum's Scientific Advisory Council, for his manuscript review. I made the statement a long time ago that the book would not be published without Walt's expertise and blessing. Now I can truly understand what he meant about how much time and energy goes into writing a book.

Most photographs in this book are derived from PTM collections. These collections are donated to the museum, and the donors may or may not be the photographers. Additionally, the same image might have been donated to the museum by several different donors, as it was common for photographs to be duplicated and distributed. Images from sources other than PTM are credited as such.

INTRODUCTION

Surrounded by the deep blue Pacific Ocean, many regard Hawai'i as a tropical paradise, where the ocean is appreciated for its beauty, recreational opportunities, and as a source of food. Our daily wind-produced waves crashing against bluffs and lapping on beaches creates incredible aquatic displays that residents and visitors never tire of viewing and photographing. But when the sea rises up and slams onto shore with unimaginable power during a tsunami, one of nature's most powerful forces is unleashed, and the devastation leaves us awestruck.

Tsunamis are caused by displacement of water on a grand scale, typically by a plate subduction event accompanied by a large earthquake. Other possible causes include aerial or submarine landslides, undersea seamount summit collapse, lava entering the sea, or meteorite impact.

Since the last major tsunami in 1960, there has been considerable economic growth and development in potential inundation zones in Hawai'i. Concomitant with this growth, there has been little destructive tsunami activity, resulting in a populace with little experience regarding tsunamis. The deadly and disastrous consequences of tsunamis are undeniable; public awareness is the key to saving lives in future events.

Hilo, Hawai'i, has suffered more damage than any other area in the islands due to the shape of Hilo Bay and the fact that Hilo had been developed right down to the ocean's edge. The devastating tsunamis of 1946 and 1960 reshaped the social and economic structure of the Hilo community. The compelling stories of tsunami survivors reveal the cultural and socioeconomic development of Hawai'i. Importantly, these stories provide a connection with the past, and together with scientific information, they educate people about this powerful force of nature.

This book provides a simple science background on tsunamis, with the bulk of the text dedicated to the powerful human stories told by survivors. The two biggest tsunami events in Hawai'i in the last 200 years occurred in 1946 and 1960, and the chapters devoted to these events are the longest. Numerous evacuations and small tsunamis occurred in Hilo in the 1950s, fostering an attitude of complacency in the populace. Locally generated tsunamis, those that are generated in our backyard, are discussed, followed by a chapter regarding the ever-present threat for Hawai'i in the middle of the Pacific Ocean and the impact that the 2010, 2011, and 2012 tsunamis had on Hawai'i.

The mission of this book and of the museum is to promote awareness to save lives, as well as to honor those lost in previous tsunami events. By combining scientific information with oral histories from survivors, the museum keeps history alive in its exhibits, publications, and public programs. Museum exhibits interpret tsunami events through photographs, videos, and interactive displays. There are exhibits pertinent to the tsunamis that have impacted Hawai'i as well as other parts of the world. Interactive exhibits include a warning center simulation and a wave machine. Scheduled talks are provided to groups.

There is a story that highlights and reinforces the museum's mission. In 2004, a 10-year-old girl who lived in England had just studied tsunamis in school. She was on vacation in Thailand

with her parents and was on the beach on December 26. She noticed the water receding, and she also noticed that no one paid attention to this phenomenon. People were actually entering the bared ocean basin to look for shells and fish. She went around to each beachgoer and told them they must follow her to high ground immediately. Fortunately, they listened, and she saved every one of their lives. That is what the museum is about—educating people of all ages in order to save lives.

Nature provides warning signs that everyone should be cognizant of. If you see a marked recession or surge of the ocean, hear a roaring sound coming from the sea, or feel a strong earthquake while at the seashore, head to higher ground immediately. If you hear the warning sirens sounding, turn on a media source to find out what has happened and how long you have to evacuate. Know whether you live or work in an evacuation zone by checking the front of the phone book or visiting the museum's web page and using the map tool to enter your address.

It is not a matter of if, but when the next tsunami will strike our shores. Be aware, be prepared, be safe, and visit the museum to learn more.

One

GEOGRAPHIC VULNERABILITY

Located in the center of the Pacific Ocean, Hawai'i is the most isolated population center on Earth, surrounded by the "Ring of Fire," where the ocean meets the continents. Called the Ring of Fire due to the extent of volcanism, the great majority of the world's earthquakes also occur in this region. The earthquakes occur because of the planet's moving plates. Hawai'i sits on the Pacific Plate, which moves three to four inches per year toward the Aleutian Islands. When one plate moves under another one, it creates tremendous stress and causes the plate to rebound upward or downward, displacing a huge volume of water. This process, called subduction, is the main cause of tsunamis. Hawai'i can be impacted by tsunamis originating from several directions.

In addition to being vulnerable due to its position in the Pacific Ocean, Hilo, on the Big Island of Hawai'i, has suffered extensive loss of life and destruction because of the characteristics of Hilo Bay, which funnels the waves in. The bay is shallow, and tsunami waves slow down and become huge walls of flooding water. Waves can reflect from one side of the bay to the other; this happened in 1960 when Waiakea Town (where the hotels are today) was devastated. The bay is shallower in the middle than on immediately adjacent sides, producing a refractive effect and focusing the energy on Hilo. Additionally, the bay faces north, where there is frequent seismic activity. Hilo Bay also has a natural seiche water movement, an oscillation with a period of about 15 minutes. If this occurs in concert with a tsunami event that has a 15-minute time interval between waves, the effect can be amplified.

Another factor that has contributed to loss of life and property in the past is that Hilo used to be a seaport town, built right down to water's edge. It was these oceanfront properties that took the brunt of the force. Since tsunami waves move up rivers, the Wailoa River area was heavily impacted in past tsunamis. Today, commercial and residential structures cannot be built in these waterfront areas. Hilo's overall appearance today can be attributed to tsunami impact planning.

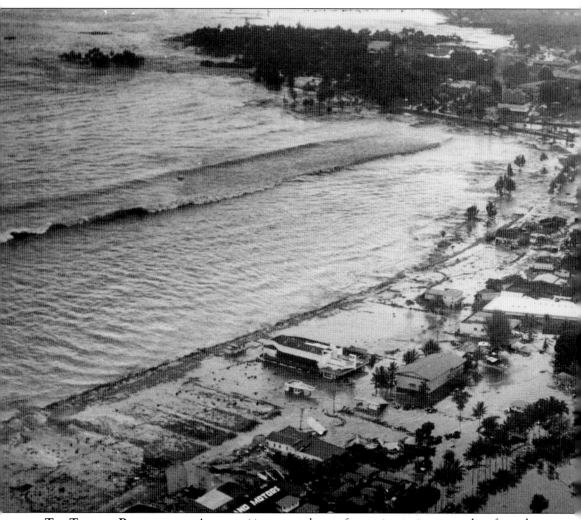

THE TSUNAMI PHENOMENON. A tsunami is a vast volume of water in motion, extending from the surface to the ocean floor, a rising of the sea. Since the energy moves through the entire water column, the bathymetry of the ocean floor affects them. Tsunamis can travel at speeds up to 600 mph (commercial jetliner speed) in deep water, although they may be only one or two feet high in the deep ocean. The experience of a Navy patrol pilot in 1946 illustrates this. The pilot saw a line moving across the deep ocean. Not knowing what it was, he called his base on Oahu and was told to reduce altitude to investigate. The radioman at the Oahu base was startled when the pilot reported that the line was moving faster than his airplane. Unknown to the pilot, the line was one of the waves in the tsunami wave train moving across the Pacific Ocean. The waves become huge as they encounter shallow water, and as they approach coastlines, they slow down, bunch up, and can become enormous. In this 1946 photograph, the waterfront area of downtown Hilo has already sustained heavy damage as yet another wave in the series comes crashing in. (James Kerschner Collection.)

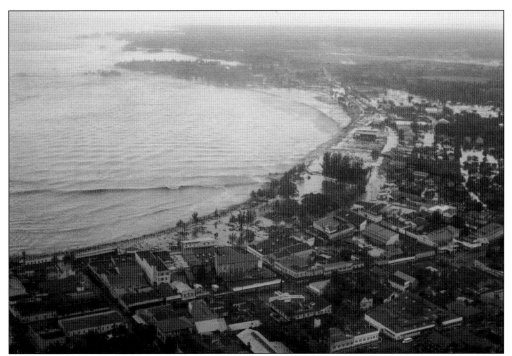

THE SHAPE OF HILO BAY. Tsunami waves have hit Hilo hard in the past due to the shape of Hilo Bay, which essentially funnels the waves in. The bay is also shallow, a feature that amplifies tsunamis. Tsunami waves can reflect from one side of the bay to the other. This photograph shows a seiche wave, a natural oscillation that can also amplify tsunami waves. (James Kerschner Collection.)

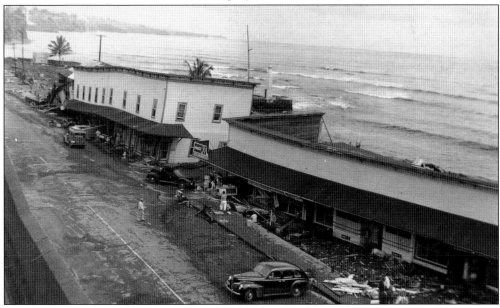

HILO: A SEAPORT TOWN. Prior to the tsunamis of 1946 and 1960, buildings in Hilo had been built right down to water's edge like these in the bayfront area. It was these buildings that were heavily damaged, moved, or destroyed in the tsunamis. Today, building is not permitted in these inundation zones, creating an open, green appearance to Hilo town. (Lee Hatada Collection.)

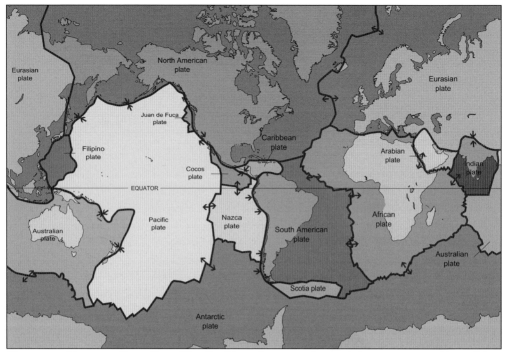

CAUSE OF A TSUNAMI, PART ONE. The Earth's surface is made up of plates, as pictured here. Most tsunamis are caused by submarine faulting in which one plate pushes under another, causing tremendous stress, with a section of the ocean floor being thrust upward or dropping downward, displacing water. This event is accompanied by a large earthquake. A series of waves is generated that can travel vast distances across the ocean. (USGS.)

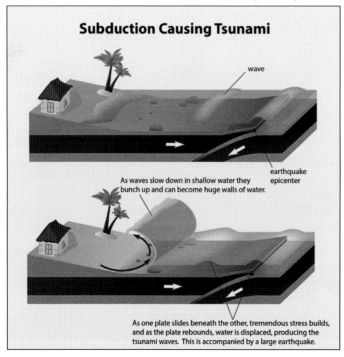

CAUSE OF A TSUNAMI, PART TWO. The geological event that triggered the 1946 tsunami was the movement of the Pacific Plate beneath the North American Plate in the Aleutian Islands area north of Hawai'i. This subduction event was accompanied by an 8.6-magnitude earthquake. The 1960 tsunami was the result of the Nazca Plate moving beneath the South American Plate in the Valdivia-Puerto Montt area of Chile, accompanied by an earthquake of 9.5 magnitude, the largest on record. (Dreamstime stock photo.)

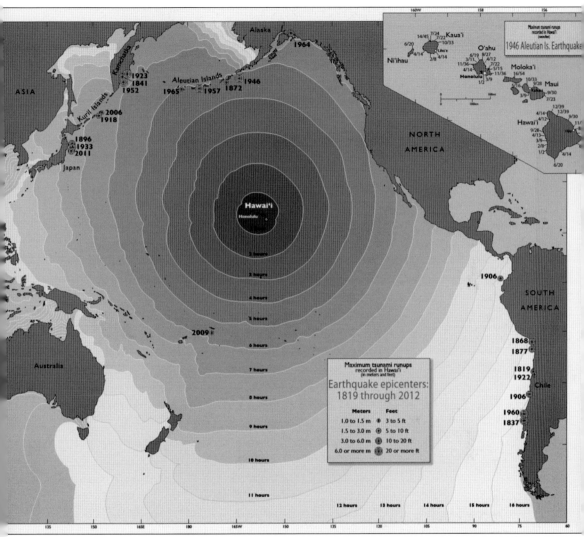

TIME TRAVEL MAP. The concentric rings on this map are intervals of hours, indicating how long it would take tsunami waves to reach Hawai'i's shores from an earthquake source. The dates represent the epicenters of earthquakes that produced tsunamis affecting Hawai'i in the last 200 years. The 1946 and 1960 tsunamis had the greatest impact on Hawai'i in terms of loss of life and property. The most recent tsunamis were in the years 2010, 2011, and 2012; Hilo was extremely fortunate that these events were nonhazardous (for Hilo). In 1946, it took five hours for the first wave to reach the Hawaiian Islands after the earthquake in the Aleutian Islands. The waves kept coming for hours. In all, 159 lives were lost throughout the islands, 96 of them in Hilo. There was no warning system in place at the time, so people were unaware of the impending danger. In 1960, it took approximately 15 hours for the first wave to reach Hawai'i from Chile, 6,600 miles away. There were 61 fatalities, all in Hilo. Waves continued on to Japan, causing loss of life and property there as well. (Dan Walker.)

13

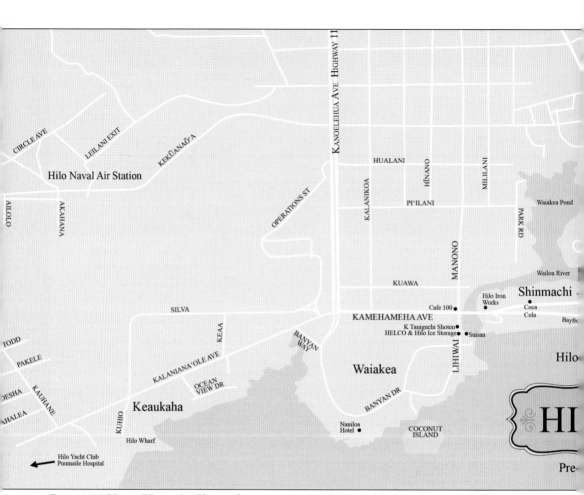

PRE-1946 HILO, HAWAI'I. Shown here is a pre-1946 map of Hilo, where much devastation occurred in the 1946 and 1960 tsunamis. The map, from Leslie Lang's *Exploring Historic Hilo*,

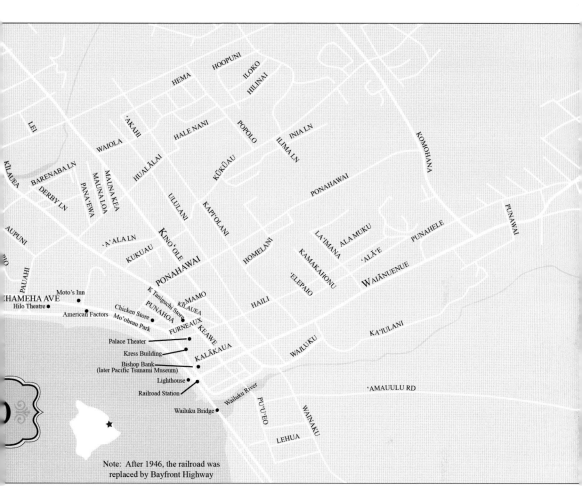

Note: After 1946, the railroad was replaced by Bayfront Highway

shows locations of streets, areas, businesses, and natural features. The breakwater, built to protect Hilo's wharf, is offshore and off the map. (Watermark Publishing.)

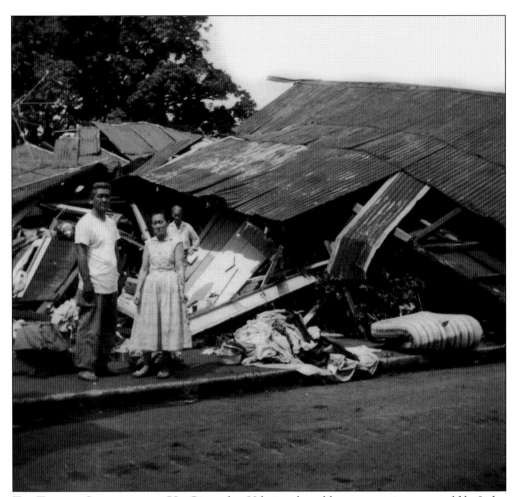

THE TSUNAMI STRENGTHENED US. Given that Hilo is vulnerable to tsunamis, a story told by Judge Terence Yoshioka eloquently describes the way in which people responded to past tsunamis in Hilo, and represents an attitude that is pervasive throughout the stories in this book. In Judge Yoshioka's words: "Life changed dramatically for the Yoshioka family on May 23, 1960. The tsunami destroyed our home and almost everything we owned. It was a miracle that no one in our family suffered a serious injury. It was after the waves had passed, and we had dug ourselves out of the debris that was once our home, that all six of us gathered next to our home, and being aware that more waves could be coming our way, I suggested to my father that we run to some nearby mango trees and climb for safety. My father then said the words that I will never forget. He said in a very calm and resigned tone: 'No. If we die, we die together as a family. . .' I simply accepted the tsunami as just another chapter in my life, and I believe the vast majority of the Waiakea community did as well. It was 'shikata ga nai,' the Japanese term meaning 'it can't be helped.' I also believe that the great magnitude of the tsunami disaster was part of the healing process. It was difficult to feel sorry for myself knowing that hundreds if not thousands of other people experienced the same tragedy. When everybody you knew seemed to be in the same boat, the only thing you could do was to 'gaman' (a Japanese word meaning to be patient or to tolerate), which is what we all did. We endured the consequences of the tsunami in anticipation of better things to come, and looking back over more than 50 years, life has indeed become better for most of us, all because we did not allow the tsunami to define us as victims, but to strengthen us as survivors." (Terence Yoshioka Collection.)

16

Two

THE 1946 TSUNAMI

In 1946, today's commercial airport in Hilo functioned as a naval air station. Comdr. C.P. Kerschner was the man in charge, sent to Hilo to decommission the air base because World War II was over. Fortunately, Commander Kerschner's personnel were still in full operation on April 1, 1946, the day of the tsunami that claimed 159 lives throughout the Hawaiian Islands.

Commander Kerschner and his family were having breakfast at the base at about 8:00 a.m. on April 1. Eight-year-old James had a cold that day and stayed home. Typically, a Navy driver would take him to a civilian school. They would have driven right along the bay, just about the time the huge 30-foot third wave hit, and would have probably been swept away.

Commander Kerschner received a call, to which he responded, "Oh yes, April Fools!" The sailor on the other end of the line said, "No, sir, this is real. We really had a tidal wave." The tsunami had come unannounced, since there was no warning system in place at that time. Commander Kerschner replied to the sailor, "Okay, this is for real, get the crash boats out, get the aircraft up with photographers in them, and try to photograph and record everything you can."

The ensuing images (many showcased here) documented the devastation that was pervasive in parts of Hilo and north of Hilo. The rail system and shipping port were heavily damaged. The waves crashed over the breakwater, and businesses of all kinds in Hilo were pushed into other buildings as if some giant had slammed, squashed, and ripped the structures open. In fact, there was a giant responsible; it was the tremendous force of a tsunami. Survivors report that before the gigantic third wave surged in, the water in the bay receded all the way out to the breakwater.

In the waves' wake, lives and livelihoods were lost. Homes were destroyed. Hilo would reel from the catastrophe, but the spirit of resilience would shine through. Hilo would not emerge unscathed, but neither would it be undone. The human aspect of the tragedy—the stories of fate, how people responded to one another and how they rebuilt—paints a picture that portrays strength and compassion.

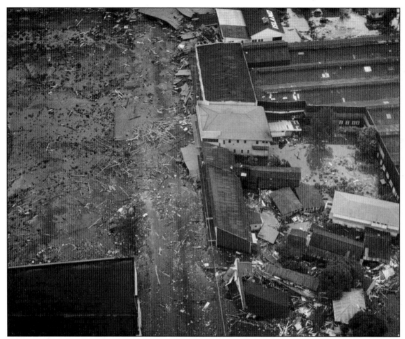

DEVASTATION IN DOWNTOWN HILO. The bayfront business district was utterly devastated by the 1946 tsunami. American Factors Lumberyard buildings and other buildings were lifted, crumbled, and shoved into buildings on the opposite side of the street, forming a big conglomeration (above). The Hilo Theater remained standing, like a monolith in a sea of splintered ruins (below). After the onslaught of each wave crest, the tremendous force of the receding water dragged structures seaward. The tsunami caused $26 million in property damage in 1946 dollars. (Both, James Kerschner Collection.)

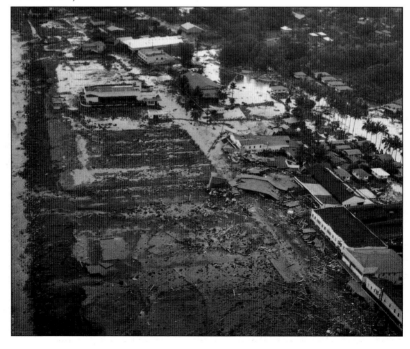

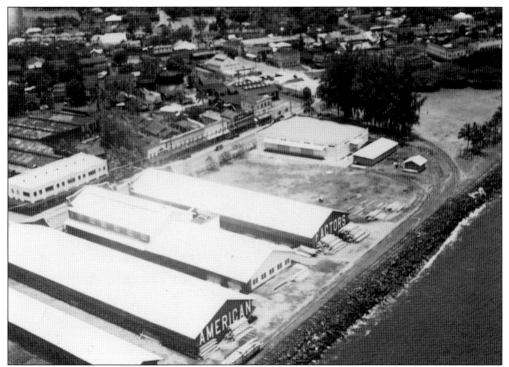

PRISTINE AMERICAN FACTORS AND RAIL TRACK. This aerial photograph of Hilo was taken prior to the 1946 tsunami and shows the American Factors Lumberyard and the railroad tracks running along the bay. The tsunami completely devastated this area. (Hiromi Tsutsumi Collection.)

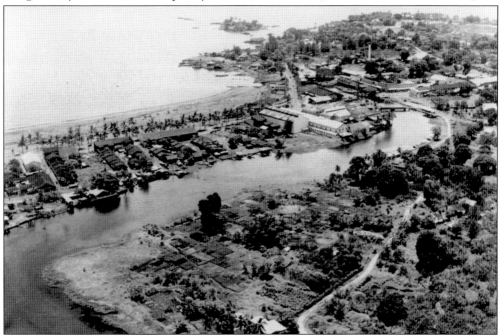

HILO PRIOR TO THE 1946 TSUNAMI. This is an aerial view of Shinmachi (with Waiakea Town in the background) before the 1946 tsunami. (Futoshi Okamura Collection.)

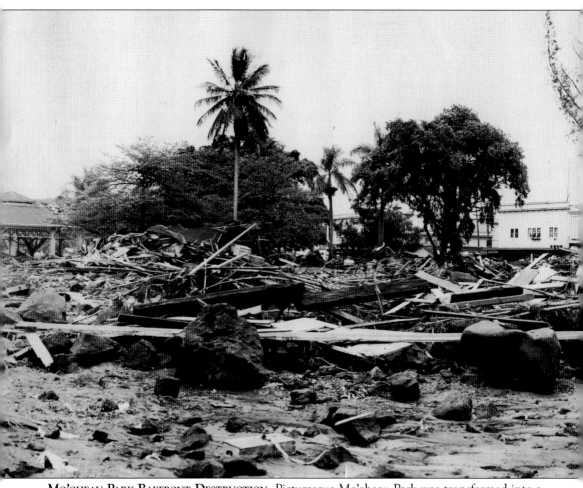

MO'OHEAU PARK BAYFRONT DESTRUCTION. Picturesque Mo'oheau Park was transformed into a debris field by the power of the tsunami waves. The Mo'oheau Park bandstand, which remained standing, is seen on the left. The destroyed downtown businesses and homes seen here once lined Kamehameha Avenue, the busy main street in Hilo. For a distance of two miles, from the Waiakea area of Hilo to Shipman Street by the Wailuku River, the town's neat appearance

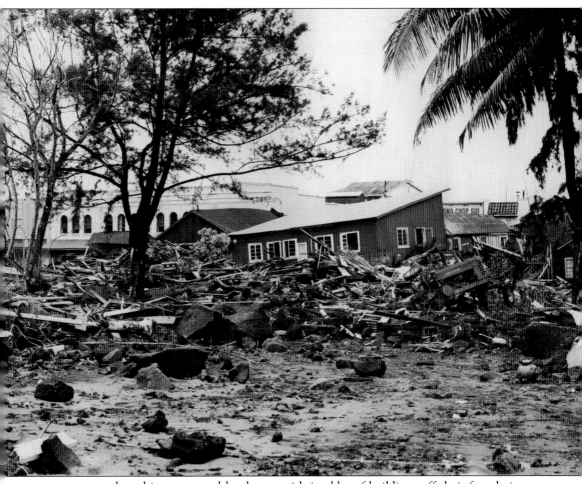

was metamorphosed into a surreal landscape with jumbles of buildings off their foundations, splintered wood everywhere, enormous boulders dropped where the waves left them, and goods and implements strewn everywhere. Parts of buildings stood at odd angles, the whole landscape a distorted conglomerate. (Donn Mori Collection.)

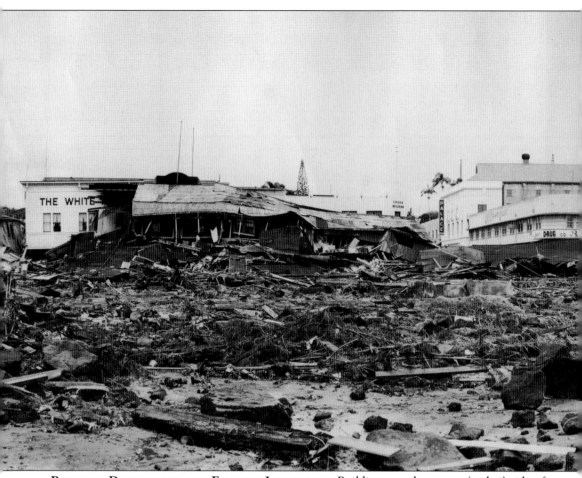

BAYFRONT DESTRUCTION AND FAMILIAR LANDMARKS. Buildings on the ocean (makai) side of Kamehameha Avenue were crumbled or pushed into the buildings on the other (mauka) side of the street. Buildings or businesses on the mauka side in this panoramic image of bayfront include the White House, Bata Shoes, D.Y. Lau, Arakawa Jewelers, Ah Mai, the Tower Building, Palace Theater, Canario Building with Standard Drug, Yamamoto Jewelry, Loo Akau Meat Market,

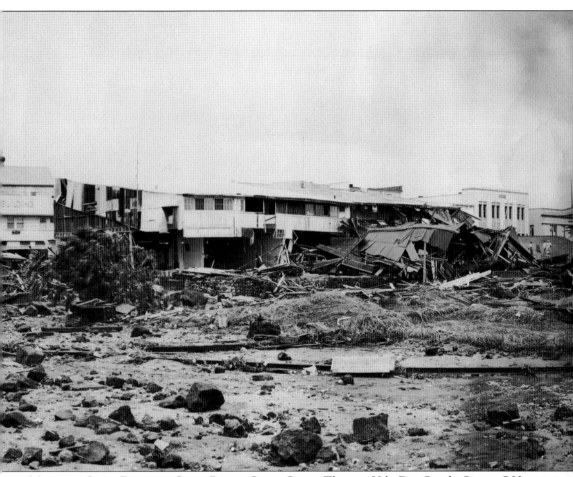

Morimoto Store, Economic Store, Boston Store, Gaiety Theatre, Hilo Dry Goods, Singer, S.H. Kress, Men's Shop, Koehnen Jewelry, American Bakery, Hilo Electric, and Bishop National Bank (today Pacific Tsunami Museum). Although the names are not visible on all of the buildings, they were derived from a map. (Donn Mori Collection.)

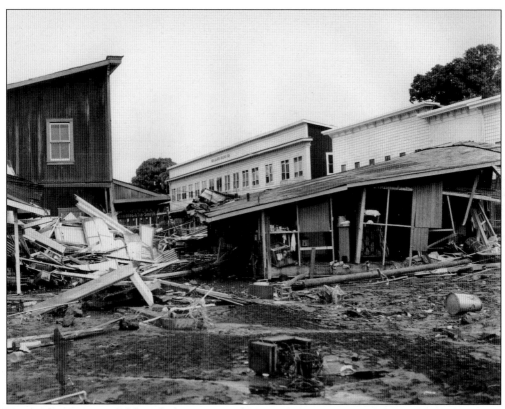

FORTUNATE TIMING. Although devastating, the tsunami's timing was fortunate. The first wave was relatively small and arrived at 7:06 a.m.; many people had already risen and wisely fled when it hit. The second, larger wave arrived at 7:18 a.m., followed by the huge 30-foot third wave. Had the devastating second and third waves struck earlier, many people would have been trapped in their homes. If these waves had struck later, employees and patrons would have been within these Hilo businesses. (Morris Lai USAAF Collection.)

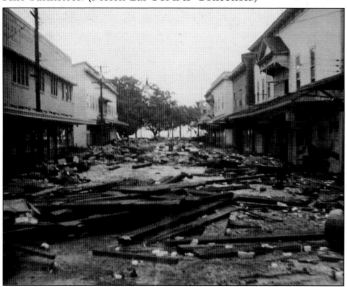

DAMAGE AND DEBRIS. This was the scene on Mamo Street after the tsunami. Businesses include the Mamo Theater on the right, Toy's Liquors on the left, Tokyo On Restaurant, and the Chicken Store. (Gilbert Yoshitaka Aono Collection.)

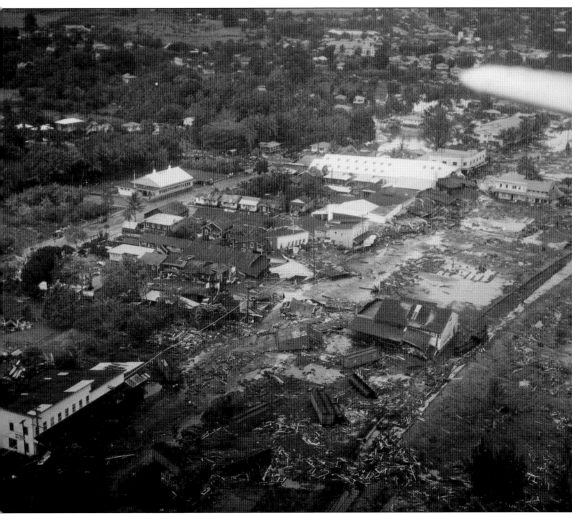

A SURVIVOR DESCRIBES WHAT HAPPENED. Dan Nathaniel Jr. observed the water receding out about half a mile from the location of the American Factors lumber building. He said, "The ocean bed was practically dry. You could see the bottom. We ran to the Wailuku River's mouth; it too was dry." "Then it began," he continued. "It started slowly. The first wave came in the direction of the lighthouse, filling the ocean bed. You could see the current race in the direction of Waiakea, hit Sea View Inn, and then swing toward Coconut Island. It struck the breakwater, crashed along Wainaku, and then came heading directly for the railroad bridge and the lighthouse point. It smashed into the bridge and went on its way of destruction," he said. "When the big wave came," Nathaniel continued, "I was standing in front of Hilo Meat Co. The next thing I knew I was hanging to the rafters for dear life, with boiling water all about me." Note the scattered rail cars and lumber in this photograph. (James Kerschner Collection.)

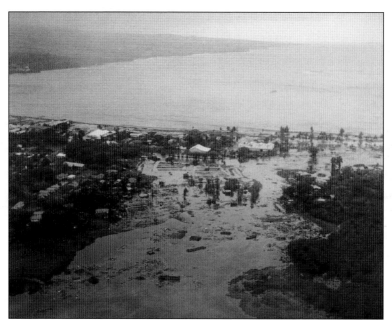

WAILOA RIVER STORY. Fragments of houses, oil drums, furniture, automobiles, and baby carriages floated in the Wailoa River, idly spinning in the eddies after the tsunami (above). Early on April 1, 1946, Yoshi Terada's father asked Yoshi to check the family boat moored in the river. Upon inspection, the boat was fine, but there was no water in the riverbed. Walking home, Yoshi saw water powerfully advancing. Realizing that he would not make it to his house, he jumped onto a neighbor's house. When he landed on the porch, he felt the houses banging together, and sensed the undeniable feeling that the house was sinking (below). And then, right in front of him, his brother's homemade surfboard appeared. He jumped on it, and the current swept him up the river, where he landed on the bank where his mother was standing. The family survived. (Above, James Kerschner Collection; below, Tsurae Higa Collection.)

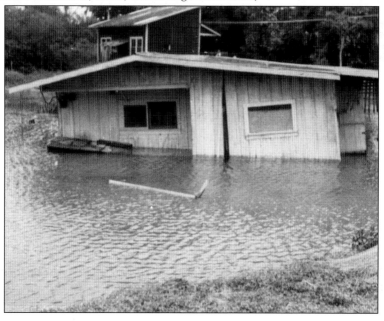

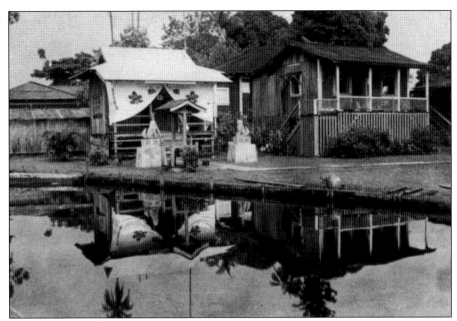

SAFE HAVEN AT THE COCA-COLA PLANT. Hiromi "Skeeter" Tsutsumi grew up on the banks of the Wailoa River in Shinmachi, a close-knit Hilo community (above). On the morning of April 1, Hiromi heard his sisters yelling "Tidal wave!" He smiled and replied "April Fool," but then he saw water rising in their yard and houses floating up the river. The Tsutsumi family sought refuge in the two-story cement Coca-Cola building. Fortunately for Shinmachi residents, the plant manager had come to work one hour early that morning. The Coca-Cola plant survived the impact of the waves, although the district around it was largely destroyed, and surrounding buildings came to rest against the plant (below, at center). The plant had afforded a safe haven for over 130 people. When the waves finally stopped, the Tsutsumi family found their home was gone. (Above, Shinmachi Collection; below, James Kerschner Collection.)

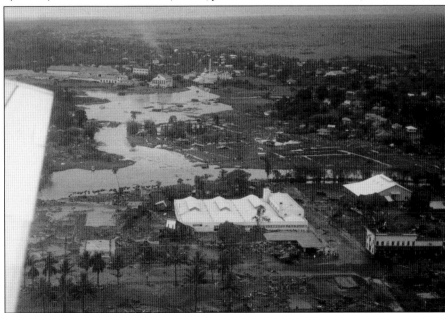

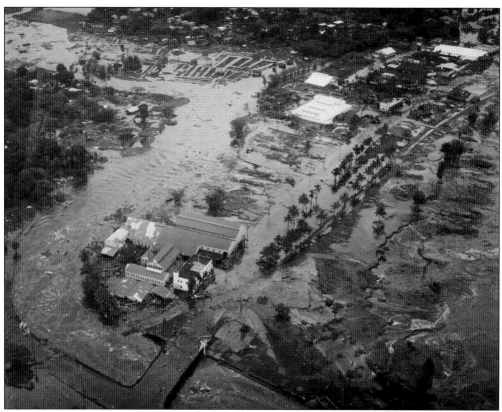

GHOSTS IN SHINMACHI. Utterly devastated, Shinmachi was largely settled by Japanese, who believed that ghosts of the deceased walked at night, hence the "Bon" dances to honor ancestral spirits. Apparitions witnessed include a deceased mother with an infant in her arms, a female ghost who disappeared when a taxicab stopped for her, and a ghost seen by a night watchman who subsequently refused to stay at his post. (James Kerschner Collection.)

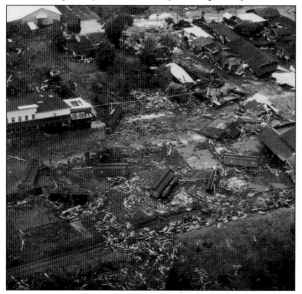

SAVED BY THE SCATTERED LUMBER. On April 1, 1946, Bill Jensen had driven from North Hilo into Hilo Town. He observed that a section of the railroad bridge by the Wailuku River was washed out. Not knowing that more waves were coming, he drove along Kamehameha Avenue just adjacent to the ocean. However, his path was blocked by scattered lumber, so he turned and drove inland, an action that saved his life. (James Kerschner Collection.)

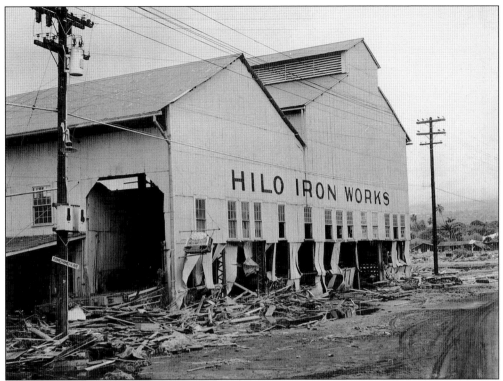

DAMAGE TO HILO IRON WORKS. Heavily damaged, the Hilo Iron Works shop was six feet under water, and machinery and electrical equipment were ruined. The ground floor of the main office was washed out. All of the office equipment was gone, and the safe was swept through the building and lodged in the back door. (Morris Lai USAAF Collection.)

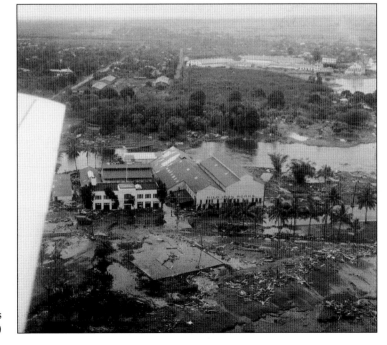

AERIAL VIEW OF HILO IRON WORKS. Both of the warehouses were gutted (center), and the contents were washed into the Wailoa River. The square concrete foundation in the foreground was a garage. No trace of it was ever found. (James Kerschner Collection.)

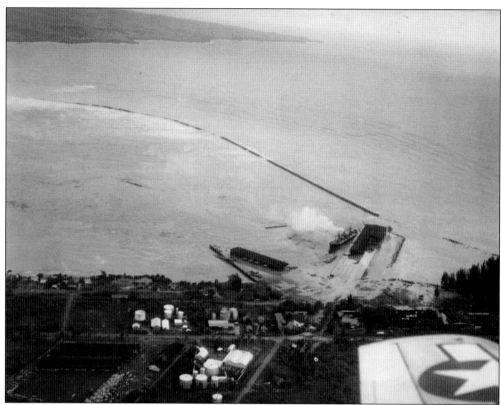

GAPS IN THE BREAKWATER. Sections of Hilo's $5 million breakwater were ripped out, the 20-ton boulders deposited inland like pebbles by the walls of water. Approximately 60 percent of the breakwater was gone in 1946. Note the ship *Brigham Victory* leaving the dock to gain the safety of the open ocean. (James Kerschner Collection.)

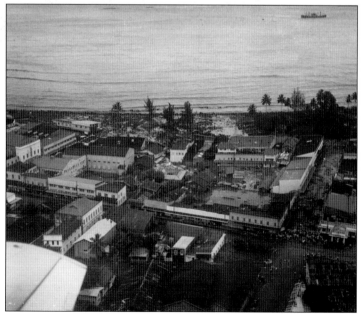

HILO RESIDENTS WERE STUNNED. Hilo residents were in a state of shock and disbelief as they gathered at the end of Mamo Street (right) to observe the destruction. It was if a giant broom had swept through the town, sweeping buildings into piles. Intersections became filled with knots of buildings. Despite the desperate circumstances, note that the *Brigham Victory* (upper right) did manage to sail safely out to sea. (James Kerschner Collection.)

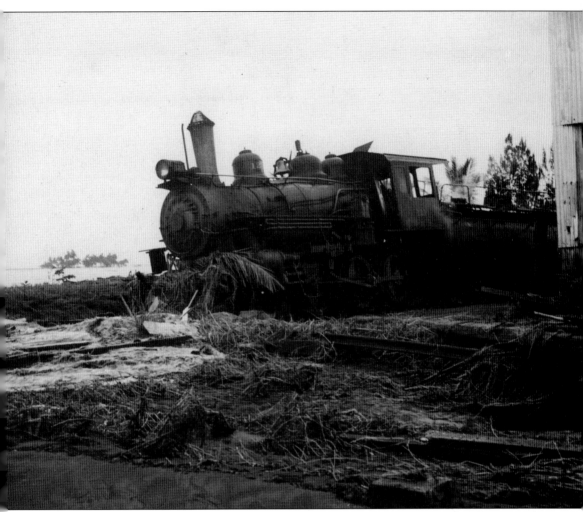

END OF THE LINE. It was a beautiful morning in Hilo on April 1. Engine 121 was pulling 11 rail cars carrying lumber, oil, and general freight, with a caboose trailing. On board, there was an engineer, conductor, fireman, and two brakemen. As the train crossed over the Wailoa River Bridge, the Hilo Iron Works 7:00 a.m. whistle sounded. The train was accelerating, traversing the area by Hilo Bay, when the engineer gave a warning shout. The fireman looked up to see a huge wave engulf the engine. As the tracks wrenched and the water hit, it sounded like thousands of thunder booms. The fireman and engineer were stunned to see the wooden boxcars splintering like matchsticks and axles and wheels crashing together. One brakeman disappeared under a pile of lumber and the other was hanging onto a building pipe. The caboose and its conductor were floating out to sea. The fireman and engineer safely made their way to the Coca-Cola building. Eventually, the caboose and conductor came to shore and beached safely into the Hatada Bakery. The brakeman extricated himself from the lumber and floated on the pile until it beached safely. All five made it out alive. But it was the end of the line for the railroad, which would never run again. (Lawrence Nakagawa Collection.)

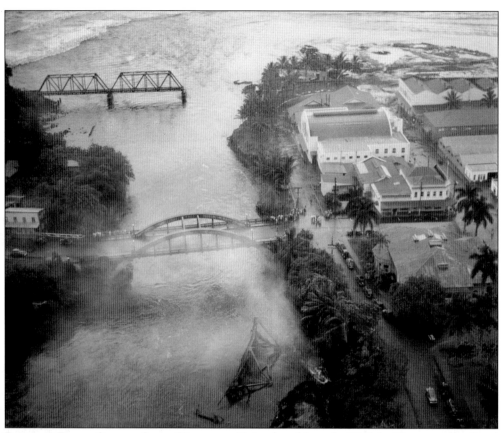

RAILROAD BRIDGE SECTION SWEPT UPSTREAM. Twisted steel from the Wailuku River mouth railroad bridge was washed 300 yards upstream. A witness saw three men pushing a small handcar on the bridge. A giant wave ripped a section off, and the men were flung into the top girders. They fell and were swept out to sea when the water receded. (James Kerschner Collection.)

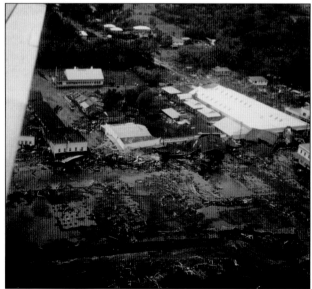

RAILROAD TRACKS WASHED AWAY. Railroad tracks along the edge of the ocean in Hilo were completely washed out and were not rebuilt after the tsunami. The Hawai'i Consolidated Railway had created jobs for people in East Hawai'i, linked people from outlying towns to Hilo, and transported sugar cane and other resources to the Port of Hilo. (James Kerschner Collection.)

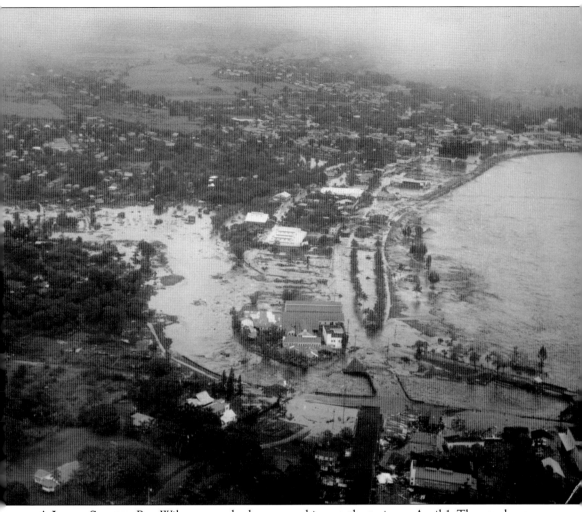

A LUCKY SWITCH. Roy Wilson was a brakeman working on the train on April 1. The coach was transporting students, farmers, and goods from Puna to Hilo. Not his normal route, Roy had argued with his dispatcher about the switch. On the new route he had to spend two nights away from home, whereas on his normal route between Hilo and Pa'auilo, he could go home every night. Roy was on the assigned Puna route on April 1, and the train set out for Hilo at 5:45 a.m., making numerous stops, including Kapoho and Pahoa. After each stop the conductor would call ahead to Hilo for the all clear, but that morning the conductor could not reach Hilo after Makuu. Moreover, Roy noticed something very unusual at Makuu. The ocean, typically blue, was brown, seemingly flowing uphill. The Hilo dispatcher informed the conductor that Hilo had just been hit by a tsunami, and they should offload all passengers, who would be bused home. The train personnel proceeded to Hilo in the empty motorcar. Roy heard that Engine 121, his usual train, had been hit by waves, and the track was undermined and destroyed along bayfront, seen here from Waiakea. If aboard the train, he could have perished. Roy was happy to find his wife safe in their home. Note how high the water is under the Wailoa Bridge in the foreground. (James Kerschner Collection.)

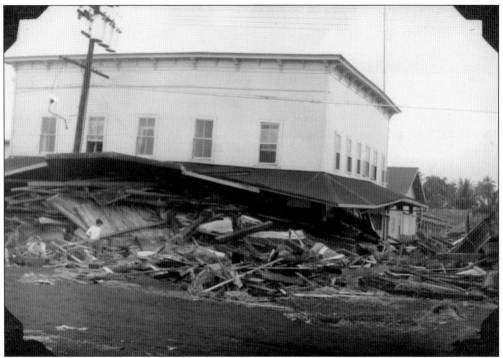

RUNNING ON THE ROOFTOP TO SAFETY. Donald Ikeda was five years old when the 1946 tsunami struck. His family lived in a two-story building fronting Hilo Bay (above). A long apartment building abutted and stretched behind the Ikedas' place. On April 1, the Ikeda family was having breakfast when Donald saw water seeping under the door. The family thought that a pipe must have broken, until they saw a fish swim by. They headed immediately for the second floor of their building. From that vantage point, Donald saw the Hawai'i Planing Mill (below) wash across the street and heard people calling for help from rooftops, only to be swept away. Miraculously, the Ikeda building remained intact. From their second floor windows, the Ikedas climbed out onto the roof of the apartments, using the expanse of the building to run to a safer area. (Above, Terumi Koya Collection; below, Aleta V. Smith Collection.)

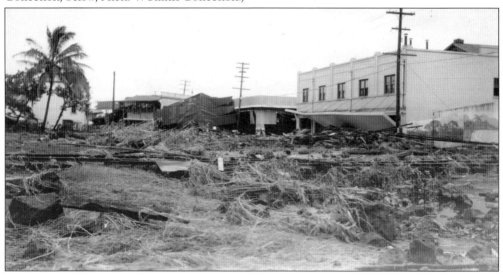

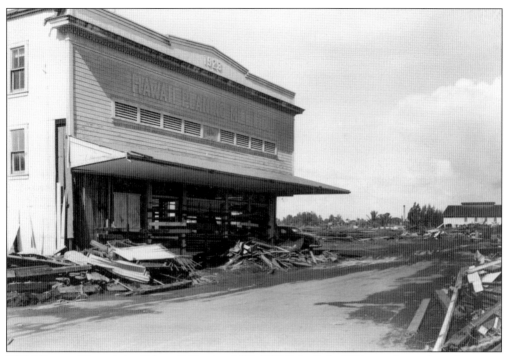

HPM Story. The original Hawai'i Planing Mill (HPM), built in 1923, was located on the ocean side of Kamehameha Avenue at Piopio Street. When the war broke out, the US Navy Seabees took control of HPM for construction projects supporting the war effort. After the war, the business resumed regular operations, but not for long. Irony would have it that the 1946 tsunami hit. (Cecilia Lucas Collection.)

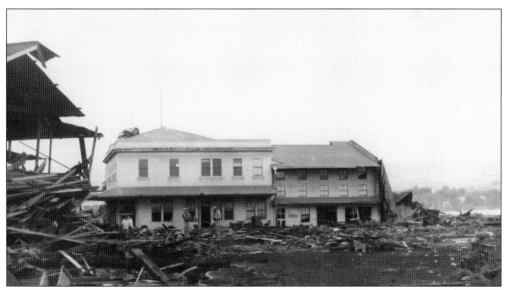

HPM Pushed into Other Buildings. This photograph shows the damage to HPM in 1946 from a side view. HPM is the lighter colored building on the left. After the tsunami, the business was rebuilt on the other side of the street by Hilo Iron Works. (Terumi Koya Collection.)

TSUNAMI SURVIVORS AT THE NAVAL AIR STATION. Thousands of displaced tsunami survivors were checked in (above), housed, fed, and cared for at the naval air station in barracks that had housed officers. Although pin-up posters were still on the walls, dazed families occupied the rooms. There was no bread or milk to be had, since the bakeries and dairies on Kamehameha Avenue in Hilo were destroyed. Warehouses that stored surplus food supplies were also gone. Personnel at the naval air station worked fervently to meet the needs of the injured and hungry survivors. Station phones rang all night as families tried to locate loved ones. Naval air station patrols picked up people who were drifting on tables and doors. Comdr. C.P. Kerschner, officer in charge of the station, is pictured below, on the top step at right. (Above, Morris Lai USAAF Collection; below, James Kerschner Collection.)

PRAISE FOR USO TROUPE.
Commander Kerschner
(right) gave praise to a USO
troupe manager (left). The
troupe stayed on to help care
for tsunami survivors after
their scheduled performance
at the naval air station the
night before. There were 13
members of the *Whatcha
Know Joe* show who helped
mothers feed children,
peeled potatoes, and tried to
cheer the disaster victims.
The troupe remained at the
naval air station for several
days to help out. (James
Kerschner Collection.)

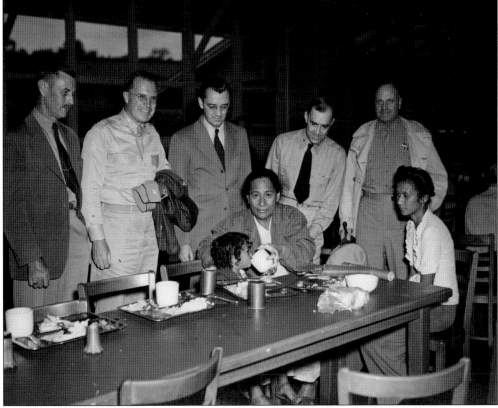

FEEDING THE TSUNAMI SURVIVORS. Within an hour of the disastrous waves, registration, medical, and food services were set up for the survivors. There were 15 trucks dispatched to pick up the survivors and bring them to the naval air station. The Navy mess, designed to feed 200 men, ramped up to feed 1,500 survivors, and 2,000 blankets, sheets, and mattresses were made available. (James Kerschner Collection.)

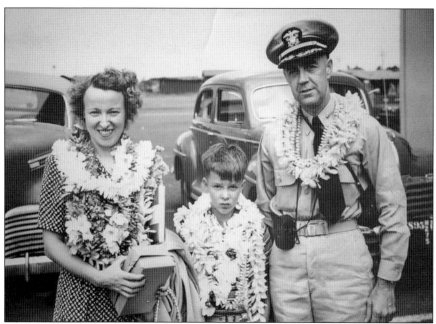

JAMES KERSCHNER AND FAMILY. James Kerschner was an eight-year-old boy in 1946 (above). Typically a Navy driver would take him to school, and they would traverse the road that ran adjacent to the ocean. However, James had a cold on April 1 and did not go to school. That was a very fateful decision, since both he and the driver probably would have been washed out to sea had they been on their usual route where the tsunami slammed ashore (below). James's father, commander C.P. Kerschner, was the commanding officer of the naval airbase in Hilo. While the family was having breakfast on April 1, Commander Kerschner received a call regarding the tsunami. Although the commander thought it was a joke at first, he quickly realized it was not, and mobilized the disaster response. (Above, James Kerschner Collection; below, Terumi Koya Collection.)

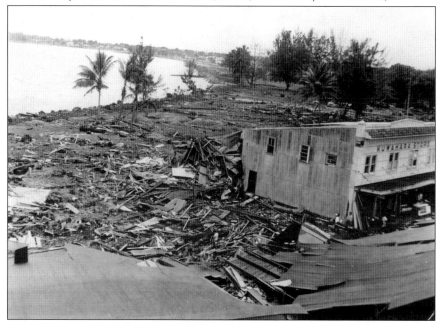

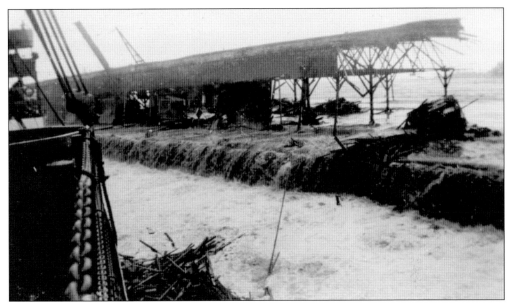

LOSS AT PORT OF HILO. The Hilo commercial piers sustained heavy damage. Pier 1 was all but destroyed and tons of bagged sugar were lost. A *Brigham Victory* crewmember took the photograph above of a wave overwhelming Pier 1. Pier 2 (below), Inter Island Steam Navigation Company's pier, sustained less damage than Pier 1, although various craft were piled up there. A wall of water that exceeded 20 feet engulfed the piers, shoving rail freight cars, trucks, warehouses, tanks, boats, and cars together. (Above, George Immel Collection; below, Gilbert Yoshitaka Aono Collection.)

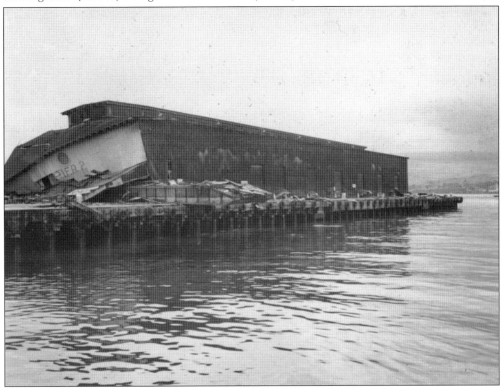

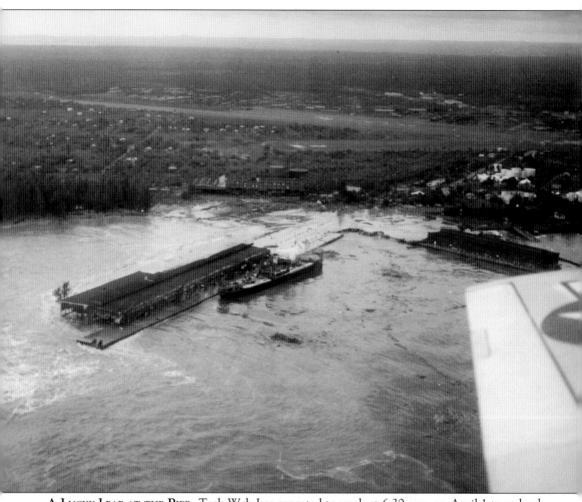

A LUCKY LEAP AT THE PIER. Tuck Wah Lee reported to work at 6:30 a.m. on April 1 to unload lumber from the *Brigham Victory*. As he "talked story" with fellow workers, someone yelled that the ocean level had dropped. Everyone rushed out to look, some even picking up fish. After checking the ship's mooring, Tuck Wah Lee climbed the Coast Guard tower at the end of the dock for a better look. As he started his descent, he saw a brown wall of water advancing, getting larger as it approached. He yelled "Run!" and dodged into the pier warehouse, jumping up a ladder to the rafters. A giant wave surged through the building just feet below him, and he saw bags of sugar floating as a small barge crashed through the building. When the water level receded, he knelt and said a prayer. He climbed down the ladder and decided that the safest thing might be to swim out to the *Brigham Victory*, now about 40 feet from the dock. He leaped into the swirling, receding water and swam through debris to the ship, climbing onboard just before another wave smashed the warehouse and washed the ship's gangplank away. The ship made it safely out to sea. (James Kerschner Collection.)

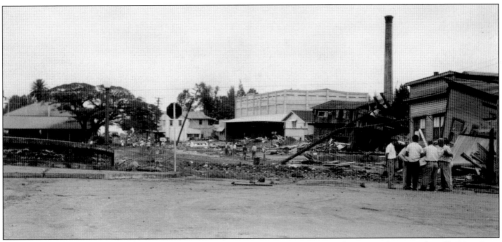

RUMBLING AND CRACKING. Sam Bishaw and his friends were on the Waiakea Bridge (left) when they observed the ocean recede and "heard this rumbling as (we) saw these huge waves come in. That was one of the most frightening things I've ever seen. All we did was turn around and run . . . And all you could hear was this crackling sound behind us. You could hear crack, crack, the buildings were piling up in the back of us." The ice plant served as a temporary morgue. (Aleta V. Smith Collection.)

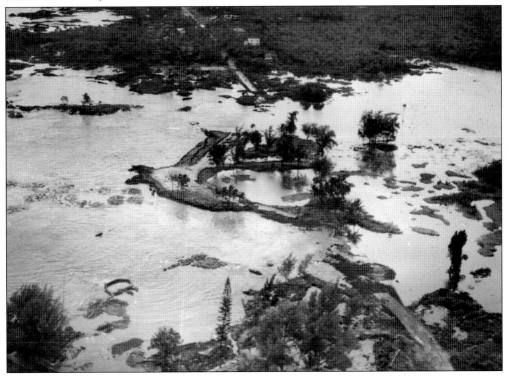

CLUBS WASHED AWAY. The only thing left of the prestigious Hilo Yacht Club was its swimming pool. Where couples had danced through the night before, the area was now devoid of the building or even its debris. The Ponds and Seaside nightclubs were also washed away without a trace. The road to Keaukaha was severed in two places in the area where the clubs had been. (James Kerschner Collection.)

KAY ISHII'S STORY. There was considerable damage at the Naniloa Hotel in Hilo (above). The ground level dining room and some guestrooms sustained damage, and the pier and boathouse were washed away. Kay Ishii, a hotel barmaid, was one of the survivors treated at the naval air station. At home making breakfast at the time the tsunami hit, she did not pay much attention to the first wave. When the second wave struck (below), it took her and the house with it, sweeping her more than 100 yards inland along with the wreckage of two other houses and the Ponds Club. She said, "I was being thrown around like a matchstick, and the force of the water was unbelievable." She remembered being washed out to sea and back again three times. Finally she was picked up, unconscious, near the destroyed Hilo Yacht Club. (Above, Waren Family Collection; below, Paulina Sorg Collection.)

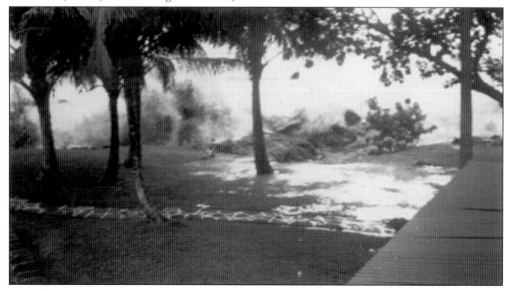

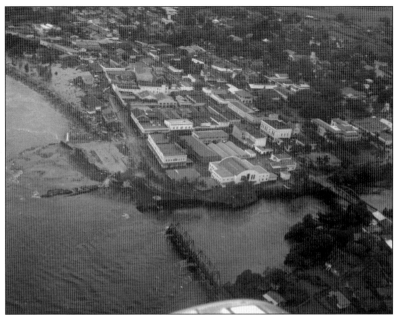

APRIL FOOL. "April Fool" is what officer Steamy Chow said on April 1 when he drove to work and a poi shop owner yelled that a tidal wave was coming. He soon discovered that it was no joke. The young policeman saw the Wailuku Bridge over the Wailuku River awash (above). He got orders to patrol Kamehameha Avenue. When he got to the corner of Kamehameha Avenue and Waianuenue, he was astonished to realize that the railroad depot was completely demolished (above and below). It looked like a bulldozer had leveled the area. Then the next wave hit. Steamy went into action and remained on duty for the next 20 hours. He painfully recalled that the ice plant was used as a morgue, where he witnessed bloated victims. He continued to do his duty over the following days, helping in whatever capacity was needed. (Above, James Kerschner Collection; below, Eklund Collection.)

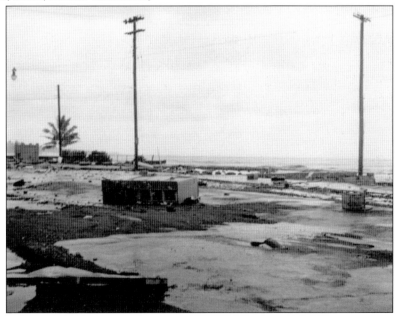

LIFE ON HILO BAY: SHAW PART ONE. Joan Yamamoto Shaw lived with her family in a second story apartment on Kamehameha Avenue. Their front window view was of lovely Hilo Bay (above), with the railroad tracks across the street on the black sand. The children loved waiting for the train and watching the workman who turned the cogs that swung the bridge across the river for the trains to cross or opened it up again for the barges that went up the river to the Canec plant. When they heard the whistle, they knew a scow or train was on the way. Looking out the back window, Joan could see the little crowded Japanese village of Shinmachi, comprised of small homes with little gardens and porches (below). (Both, Shinmachi Collection.)

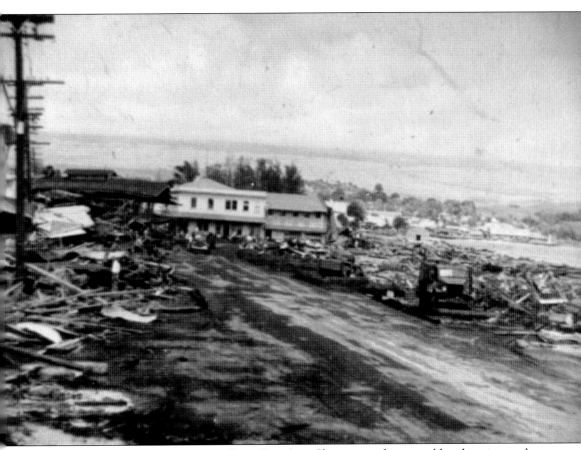

The Day Hilo Bay Emptied: Shaw Part Two. Joan Shaw was eight years old and getting ready for school on April 1. Joan's mother and the children watched in disbelief as Hilo Bay emptied out. When the first wave came in and was thigh-high, Joan's mother panicked; as the second wave came in, she gathered the children in the kitchen, breaking the windows with a hammer in case they needed to escape. Joan, a curious girl, returned to the front window to watch. She saw the terrifying sight of the incoming water carrying huge boulders, and ran back to the kitchen just as the apartment's wall collapsed. The third wave was higher than their apartment. As she was jostled about, her foot got caught within the collapsing wall. Her immediate thought was "Oh, is this how it feels to die?" Her mother ended up on the rooftop and reached to pull Joan up. They floated into the Waiakea Pond where her mom applied a tourniquet to her leg. Rescuers from the Canec Plant and the plantation houses came in boats to rescue those floating in the river. Joan, a sister, and her mother ended up in the hospital. Two sisters and a brother found each other at the Red Cross station. Three-month-old Clifford and three-year-old Lorna perished, having been washed from their mother's arms. (Shinmachi Collection.)

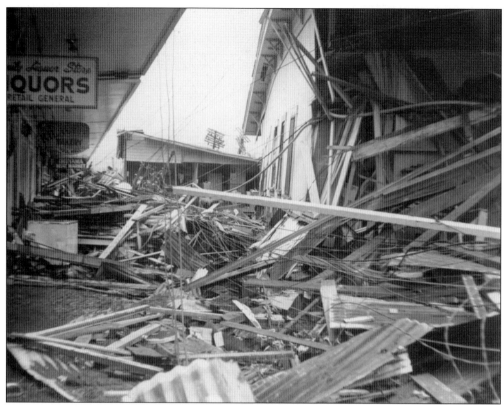

GETTING AROUND. Roads were impassable due to debris or flooding water. The photograph above, taken on Kamehameha Avenue in Waiakea, shows Family Liquor Store, Retail General, Kilauea Bakery, Okuyama Meat Market, and the pool hall. The photograph below illustrates the flooding that made a boat the mode of transportation in this area of Shinmachi. (Above, Gilbert Yoshitaka Aono Collection; below, Grace Ogata Collection.)

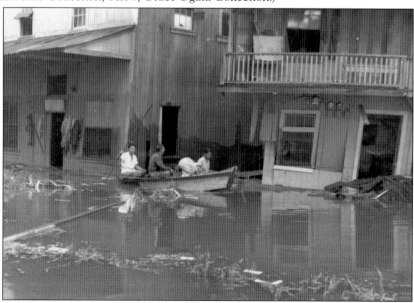

A Chicken Story. In the old days, people bought chickens, local foods, and herbs at the Chicken Store on Mamo Street (above). Laura Yuen Chock's parents (below) owned and ran the store, and the family worked there. On April 1, 1946, Laura saw the first tsunami wave come in. She described Mamo Street as looking "like Venice—water covered the street." After the second wave, the family sought higher ground, making it safely to Kinoole Street. Returning to the store the next day, they found that the building was intact; they were even able to salvage some of the goods. The store reopened in about a month. (Both, Tai On Chock Collection.)

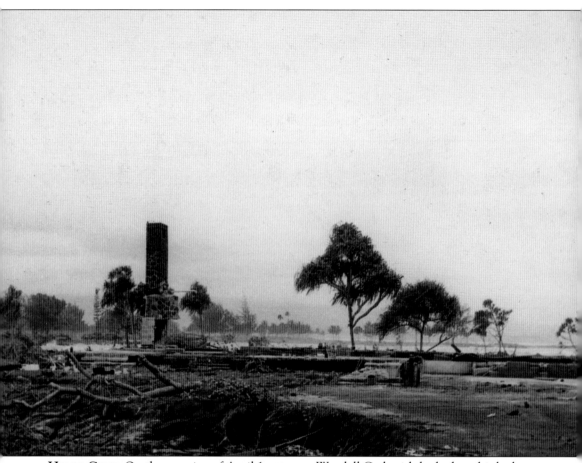

Homes Gone. On the morning of April 1, attorney Wendall Carlsmith looked out his bedroom window in the Keaukaha area of Hilo and saw the first wave approaching. Although not very large, it was moving fast. He grabbed his robe as his wife got the children into the car. As they ran out of the house, water lapped at their feet. When they got as far as the home's tennis court, they observed the water receding, and returned to the house to see if it sustained damage. Observing that another wave was coming, they ran back to the tennis court. The second wave was larger than the first and struck the home's foundation. The family made its way to a neighbor's home on higher ground and saw the next wave approaching. This wave rolled over the house and across the highway. When the wave ebbed, the Carlsmiths could not see anything of their house except the chimney and the tennis court. The furniture was gone, and the grounds were inundated. Days later, redwood beams from the home were found miles away. The Carlsmith home is one example of the many homes that were damaged or completely destroyed and washed from their foundations. (Jeanne Johnston Collection.)

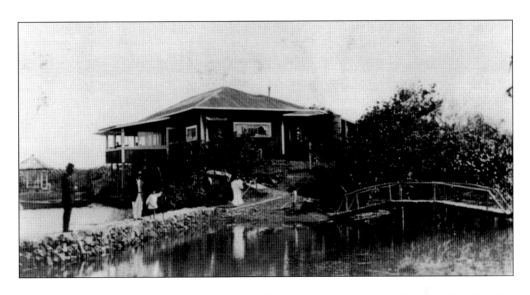

THE SEASIDE RESTAURANT SAGA. The Seaside Club Restaurant stood on stilts (above) at the edge of Lokoaka Pond in Keaukaha. Customers could look down and see the aholehole fish swimming, fish that would end up on the diners' plates. On April 1, the Nakagawa family had no warning of an impending tsunami. Larry Nakagawa had just risen from sleep when he heard an odd sound, "like if you were to take a bucket of pebbles and throw it on the concrete." Larry's brother said it must be a tsunami, and everyone should climb trees. Perched high, the family saw a wall of water (below) push the restaurant and family homes into Lokoaka Pond. Sadly, Larry's aunt perished. Eventually the family salvaged what they could and embarked on rebuilding. On July 27, 1947, the new Seaside Restaurant opened. The restaurant is open today, an island favorite serving delicious meals. (Above, Sumie Miyasaki Collection; below, Fumiko Hata Collection.)

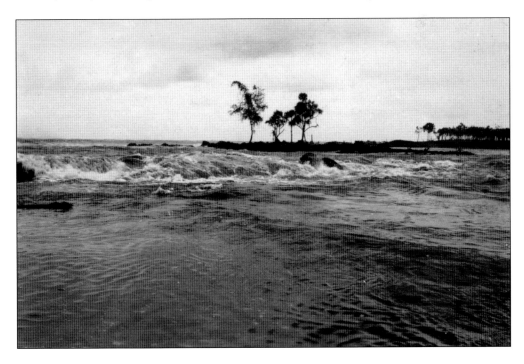

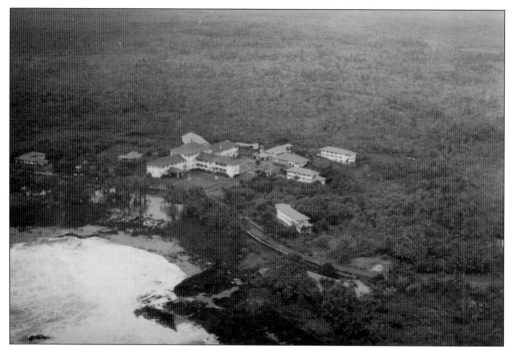

PUUMAILE HOSPITAL SPARED. The hospital in Keaukaha was spared by the tsunami. The Army installed standby generators until power could be restored. Engineers laid two miles of emergency pipeline to restore water. Patients were evacuated by Navy personnel and cared for at the naval air station. (James Kerschner Collection.)

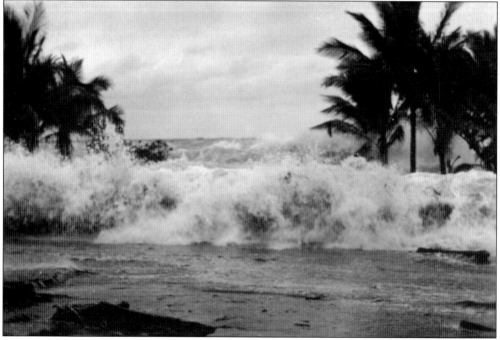

INCOMING WAVES. Pictured here is one of the waves advancing over the seawall at Puumaile in Keaukaha near the hospital. (Francine Ancheta Collection.)

50

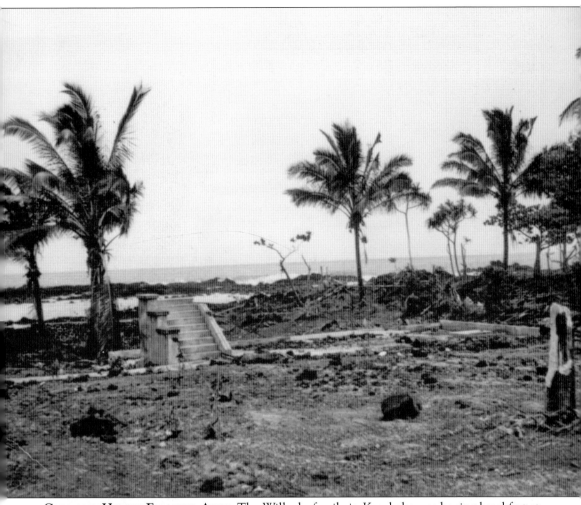

CARS AND HOUSES FLOATING AWAY. The Willocks family in Keaukaha was having breakfast at about 7:00 a.m. on April 1, and it sounded like it was raining outside. The father and son went outside to look and observed that the ocean was receding. As they walked across the lawn, the father fell through the grass sod a few feet, landing on rock. The first wave of the tsunami had sucked the dirt out from underneath the lawn, but the grass was still there. They went back inside the house and saw the water rising. Hugh, the son, said "It wasn't really like a wave; it was just like a high tide coming up. The cars were literally floating up out of the garage backwards towards the road." The family left for higher ground when the house started to lift up. In the end, the only thing left of their house was the rock stairs, similar to those pictured here. The family was taken to the naval air station for refuge. (Lenore Van Geison and Martha McNicoll Collection.)

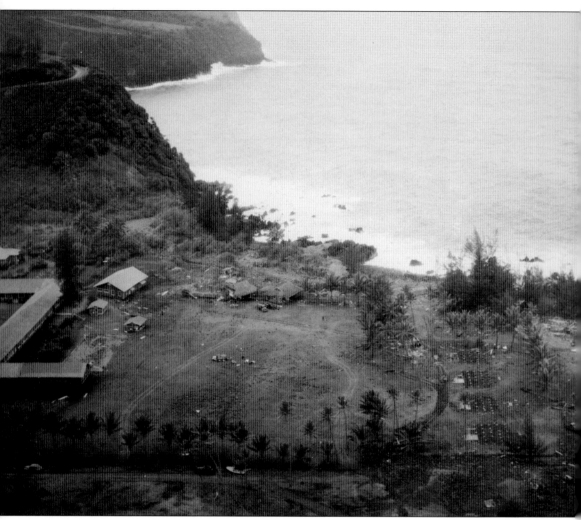

A FATEFUL STORY AT LAUPAHOEHOE. Laupahoehoe Peninsula, located about 23 miles north of Hilo, was an idyllic place to go to school. Tragedy would unfold on the morning of April 1, 1946, when tsunami waves crashed onto the peninsula, taking the lives of students and teachers. Through a lucky quirk of fate, student Joretta Ignacio was spared. Joretta was usually on campus by 7:00 a.m. She would wait for her friend, Janet DeCaires, to arrive, and they would walk down to their oceanfront teacher's cottage to sit. However, on the morning of April 1, Joretta's mother insisted that Joretta stay home to practice piano before going to school. Afterward, Joretta's father drove her to school. At the peninsula overlook, they found that cars were coming up and people were shouting, "Big waves!" They saw a wall of water envelop the point, and the ocean made a roaring sound. The teachers' cottages were demolished (note the empty house pads at right), swept from their foundations. Tragically, Janet, Joretta's friend who had been waiting on the back steps of the teacher's cottage, was swept to her death. Joretta's life had undoubtedly been saved by staying home and practicing piano. (James Kerschner Collection.)

TRAGEDY AT LAUPAHOEHOE. April 1 was like any other school day for the students and teachers at Laupahoehoe School. Before class, students fished, picked up limpets (opihi), or played on the swings. Teachers lived in oceanfront cottages. Helen Kingseed, Fay Johnson, Dorothy Drake, and Marsue McGinnis were bright, new teachers from the mainland who resided in one of the cottages (above). As they were having breakfast, a student told them to check out the "tidal wave." The teachers joined many others who headed to the shoreline. The massive third wave split the teacher cottages into ruins (below), carrying buildings inland, followed by the receding water pulling everything seaward. (Both, Leila and Fred Bruce Collection.)

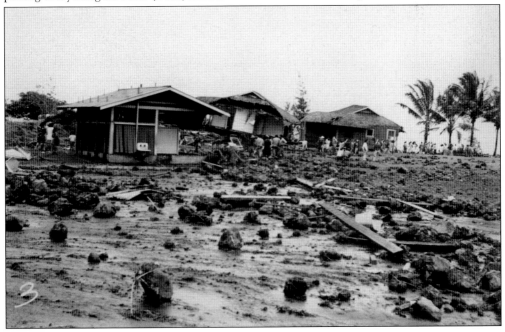

AMAZING RESCUE AND PROPOSAL. As Laupahoehoe teachers Helen Kingseed, Fay Johnson, Dorothy Drake, and Marsue McGinnis tried to escape the massive waves, the turbulence tore their cottage apart. They tried to cling onto the cottage roof, but the force of the water washed them out to sea. Marsue lost her grasp on Helen. Then Marsue felt her body being thrashed about like a doll. Finally surfacing, she saw a great deal of debris in the swirling water. Cold and in pain, Marsue was carried farther and farther from the coast. Hours passed and night fell. In the distance she heard an engine and then saw a tiny boat. In the boat was Dr. Leabert Fernandez, with whom she had made a date that very evening. As he rescued her, he said, "Say you'll marry me or I will throw you back in." She said yes. This photograph of Marsue and Dr. Fernandez was taken on the occasion of the 1948 commemoration at Laupahoehoe. (Nira Kurihara Collection.)

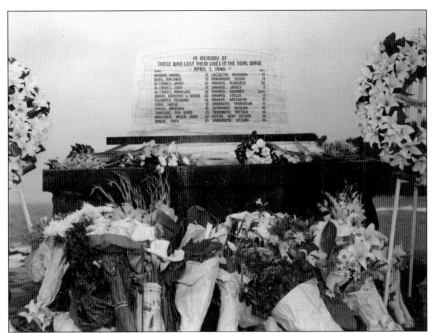

COMMEMORATING THOSE LOST AT LAUPAHOEHOE. The Laupahoehoe Monument was dedicated in 1948 (above). The state donated the land, and the monument was paid for by donations. In all, 24 people perished at Laupahoehoe, including 16 children, four teachers, and four residents. Survivors described the water as roiling, coming from all directions. Whirlpools or churning water sometimes occur during tsunami events. Cottages and other buildings were observed to be floating and spinning. The water was chock full of boards and branches. Some children were caught in bushes that saved them from being washed out to sea (below). (Both, Leila and Fred Bruce Collection.)

THE SMELL OF ORCHIDS. On April 1, Anthony Lacuesta, a senior at Laupahoehoe School (pictured), did not want to go to school. His mother had to tell him to leave several times. When he finally left, he returned a short time later to retrieve his blue jacket and then set off. Sadly, after the tsunami on that fateful day, Anthony never came home, and his body was never found. His mother was inconsolable. An amazing experience would provide solace for the family. Anthony, who was always close to his older sister, would often bring her wild orchids for her hair. Three days after the tsunami, the Lacuesta house was permeated with the scent of wild orchids. Enigmatically, the orchids were not in season at the time. Anthony's mother felt that this was a sign that Anthony was at peace and would not be returning. (Sadao Aoki Collection.)

HAKALAU MILL. Also north of Hilo, the 40-year-old Hakalau Sugar Mill (center) was destroyed. The mill had an annual output of 26,000 tons of sugar, and included a factory, laboratory, warehouse, and oil room. When the tsunami struck, water streamed through the structure like some strange funnel system. The eighth wave smashed into the machine shop and swept this part of the factory away. It lifted the clarifier, which was filled with 200 tons of juice, sending it upstream 500 feet. (James Kerschner Collection.)

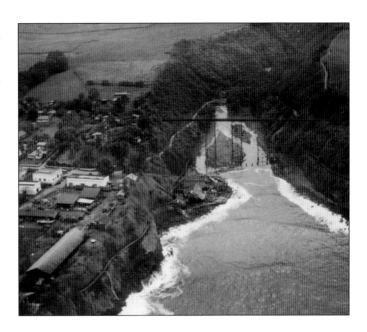

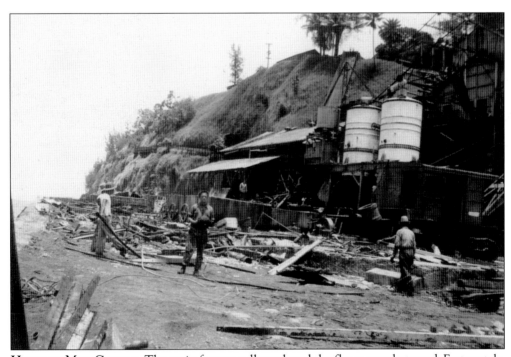

HAKALAU MILL GUTTED. The main factory collapsed, and the flume was destroyed. Fortunately, the 40 workers evacuated. In the end, the building was gutted, machinery was smashed, and the surrounding property was inundated. Parts of the buildings were carried out to sea while others ended up in Hakalau Stream. Huge trees fell as if they were cane stalks. Valued at more than $1 million, the mill was now a gutted skeleton. (Howard E. Seacord Collection.)

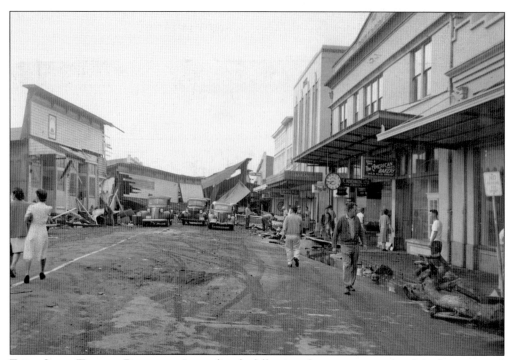

FIRST STEPS TOWARD RECOVERY. Immediately following the tsunami on April 1, observers said it would take months for businesses to resume in the hardest hit areas. However, on April 9, a number of establishments reopened. The Kress Store, Hilo Photo Supply, Beamers Hardware Store, Singer Sewing Machine Company, Hilo Electric Light Company, American Bakery (above), and a few others passed a rigid test by the board of health and opened for business. Additionally, Consolidated Amusement Company's Palace Theater (below) reopened, giving the town a morale boost. The theater suffered no interior damage, although debris was piled up high in front of the building. The Palace Theater showed movies actually slated for the Hilo Theater, which was heavily damaged. (Above, Andrew T. Spalding Collection; below, Aleta V. Smith Collection.)

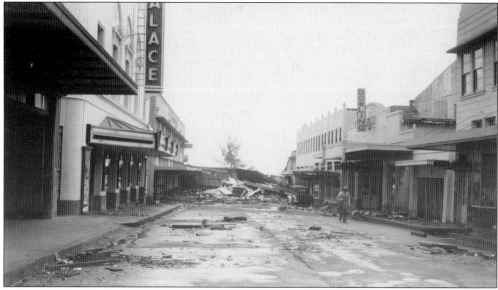

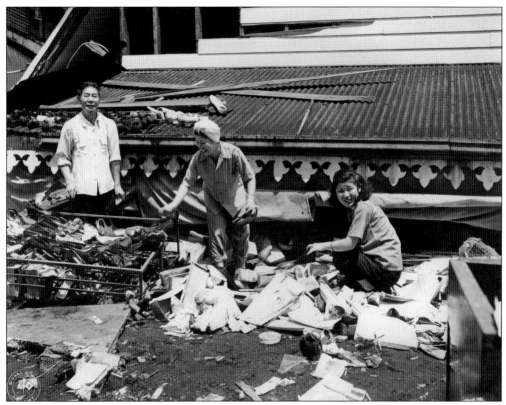

A Spirit of Rebuilding and Moving Forward. Cooperation and cheerful resolve prevailed as people helped one another to clean up after the disaster. Here, M. Minato, owner of a dry cleaning establishment, K. Yamanchi, and Y. Kawachi help to gather the scattered merchandise of a neighboring shopkeeper on Kamehameha Avenue. (Morris Lai Signal Corps Collection.)

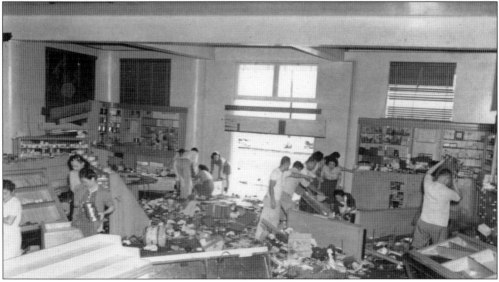

Interior Store Cleanup. Friends and neighbors help each other to undertake the massive cleanup in Hilo. (Gilbert Yoshitaka Aono Collection.)

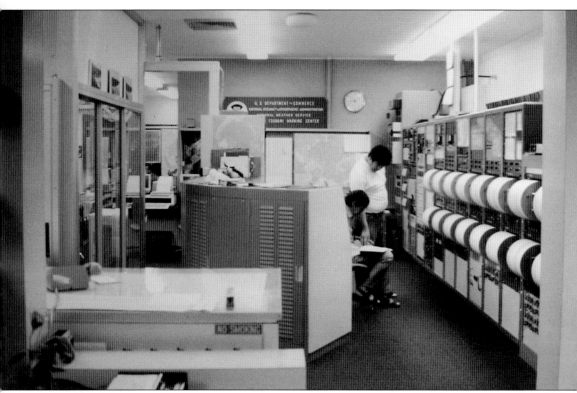

WARNING CENTER BUILT. There was a silver lining to the 1946 tsunami: a tsunami warning system was established. In May 1946, Dr. Thomas A. Jaggar, noted volcanologist, was quoted in the *Hilo Tribune Herald* regarding the need for a warning system. He stated that new inventions might lessen loss of life from tsunamis. Specifically, he stated, "The seismographs in Honolulu and at the Hawai'i Volcanoes National Park showed a very severe earthquake five hours before the tidal wave arrived. The earthquake origin of the waves may actually be calculated and the approximate size of the wave and its time of arrival forecast." He went on to say, "Large swings of the arm of the seismograph needle are very clearly recorded on moving paper. The wide swings have been made to set off an electric bell, and could awaken an attendant. News might be sent to all islands in time to get people back from the shores and low areas." By 1948, an official tsunami warning system at the Pacific Tsunami Warning Center (PTWC) at Ewa Beach, Oahu, had been established. Since then, there has been tremendous technological advancement in forecasting and modeling of tsunamis. The PTWC is pictured here between 1960 and 1970. (Brian Shiro, PTWC.)

Three

THE 1950 TSUNAMIS

The 1950s are fondly remembered by many as "the good old days." The Waiakea area of Hilo was thriving with businesses and homes. As idyllic as the 1950s were, the decade was jarred by numerous tsunami warnings and evacuations, followed by relatively small waves in Hilo. Small waves were good, but complacency was not. Some residents started to regard tsunami warnings as false alarms.

On November 5, 1952, a magnitude 9.0 earthquake in Russia's Kamchatka Peninsula produced a tsunami with 20-foot-high waves striking the local coast. Farther south, the Kuril Islands experienced 65-foot waves. On the island of Oahu in Hawai'i, a nine-foot wave flooded Sand Island, and waves surged in and out of the Ala Wai boat harbor. There was flooding in Kahului, Maui, and the Big Island experienced a 12-foot surge over Coconut Island and at the Hilo commercial pier.

The warning system implemented in 1948 was successful in preventing loss of life. Yet it was disturbing that when the sirens sounded, some people approached the ocean instead of heading away from it.

In 1957, some people responded similarly, heading toward the shoreline to watch. This tsunami was generated by an 8.6-magnitude earthquake in the Aleutian Islands. One of the waves was as high as 75 feet on Unimak Island, Alaska. Waves raced toward the Hawaiian Islands, where a 32-foot wave struck Haena, Kauai, leaving only four of 29 homes standing. Wainiha and Kalihiwai villages were wiped out too, and areas were isolated as infrastructure was destroyed. The north shore of Oahu experienced a rapidly rising sea. When the waves struck Hilo, the wharf was flooded at Pier 1 and waves washed over Coconut Island.

The 1946 and 1957 tsunamis were similar in some ways and different in others. They both came from the Aleutians, with similar speeds and wavelengths. However, Kauai was more heavily damaged in 1957 than in 1946, while the reverse was true for Hilo. A salient generalization emerges: Tsunamis are very complex events, and many factors play a role in the outcome, including bathymetry offshore, topography onshore, presence or absence of reefs, bays, and rivers, and orientation of the Hawaiian ridge.

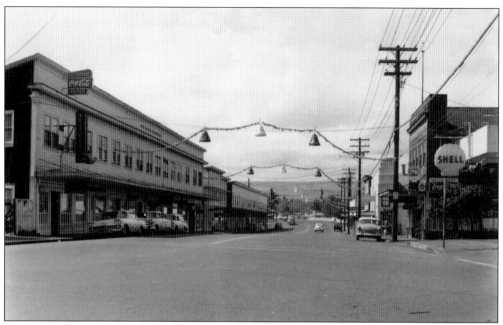

THE IDYLLIC 1950S. This photograph of Kamehameha Avenue in Hilo's Waiakea Town was taken at Christmastime in the 1950s. (Howard Pierce Collection.)

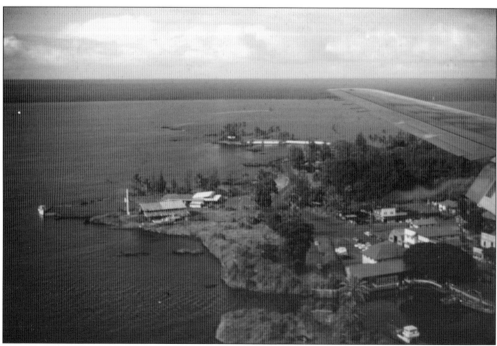

WAIAKEA PENINSULA. This is an aerial view of the Waiakea Peninsula and Coconut Island in 1956. It was a thriving area of businesses and homes that were destroyed by the 1960 tsunami. Today, there are tsunami-resilient hotels, a park, and golf course in this area. (Howard Pierce Collection.)

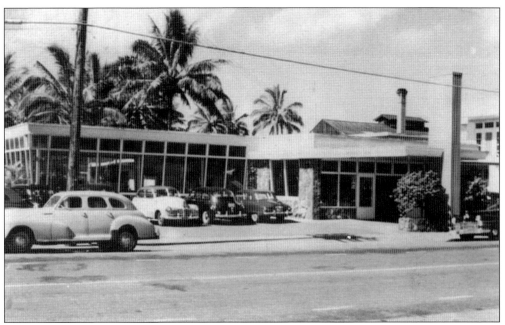

MOTO'S INN. Moto's Inn was a popular restaurant that opened in 1933 in Hilo. Many local people, as well as servicemen during World War II, ate there. Everybody loved the burgers, steaks, and pies. The original building on Kamehameha Avenue was destroyed by the 1946 tsunami. A new concrete building with a lava rock façade and large windows was constructed on the same site in 1947. This building was destroyed in the 1960 tsunami; only the concrete floor was left. (Russell Oda Collection.)

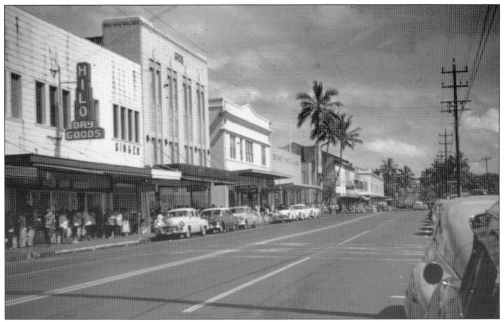

KAMEHAMEHA AVENUE, 1950s. Hilo, the quaint town on the bay, is shown in this view looking toward what is now the Pacific Tsunami Museum building (by palm tree), which was a bank at the time. (Howard Pierce Collection.)

WAILOA RIVER RECEDES IN 1952. As the river receded in 1952, fishing boats were grounded. Crowds watched the phenomenon as the river bottom became exposed. Waiting and watching, accompanied by growing complacency, marked the 1950s attitude toward tsunamis. (Ken Fujii Collection.)

WAILOA RIVER SURGES IN 1952. This photograph shows the fourth wave surging in at about 18 to 24 feet. The previous wave, the third and largest, splashed over the riverbanks onto Manono Street. Kenneth Fujii (the photographer) was not able to take that photograph, as he was running away. The third wave deposited the fishing boat onto the bank of the river. This fourth wave washed the second fishing boat onto the bank, and sank the rowboats in the distance. (Ken Fujii Collection.)

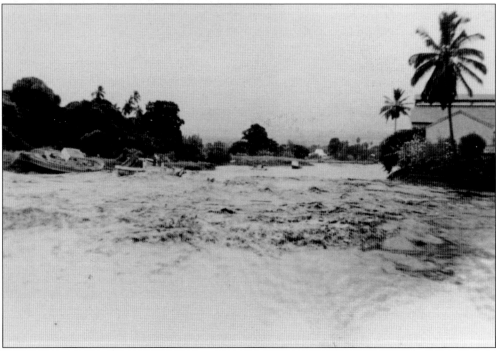

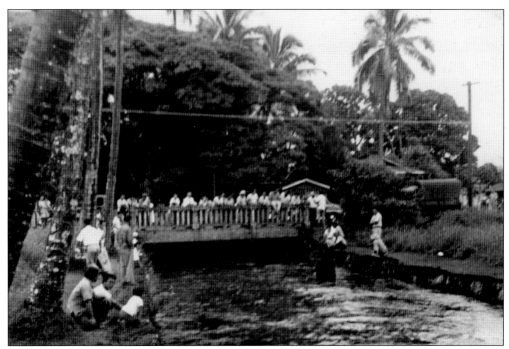

WAITING AND WATCHING. Crowds gathered at the Waiolama Canal Bridge on the Big Island as a wave advanced upstream during the 1957 tsunami. (Seiji Aoyagi Collection.)

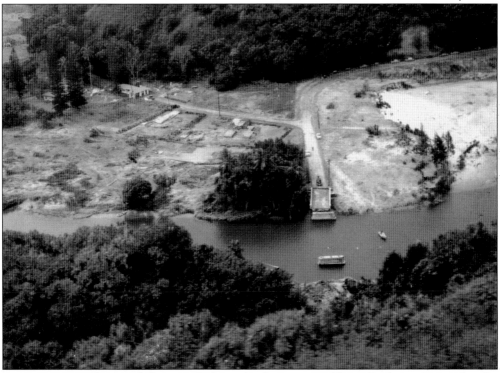

KAUAI IN 1957. This aerial photograph shows the damage to Kalihiwai Bridge on Kauai after the 1957 tsunami. (Arthur Rice Collection.)

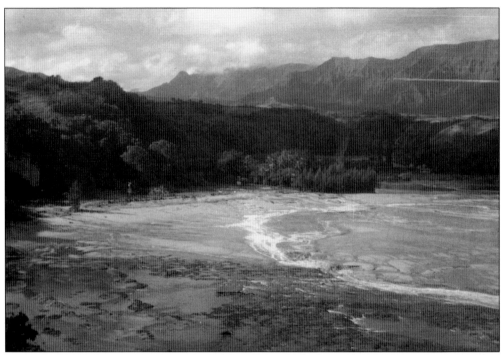

RECEDING WATER AT KALIHIWAI, KAUAI. This photograph shows the water receding out before the third wave crest in 1957. (Rev. Samuel N. McCain Collection.)

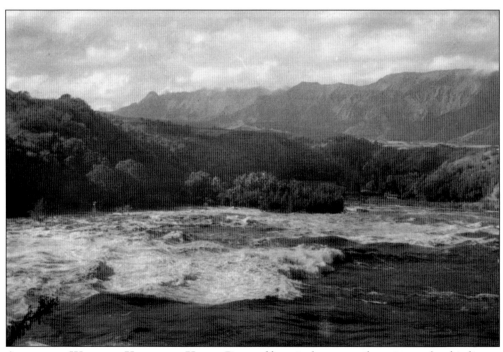

ADVANCING WATER AT KALIHIWAI, KAUAI. Pictured here is the water advancing as the third wave arrived in 1957. (Rev. Samuel N. McCain Collection.)

Four

THE 1960 TSUNAMI

On May 22, 1960, a 9.5-magnitude earthquake, the largest on record, shook the Valdivia–Puerto Montt area of Chile. Locally, the resulting tsunami devastated buildings and killed 2,000 people, causing damage exceeding $417 million. The tsunami waves raced toward Hawai'i, arriving about 15 hours later. The first wave came in just after midnight on the new day of May 23. A larger second wave came in. At about 1:00 a.m., the ocean receded seven feet below normal. This was followed by the enormous 35-foot third wave, a wall of flooding water accompanied by the sound of a dull rumble like a train approaching, and bright blue and white electrical flashes as the power grid was slammed. Buildings grated together, crumbling into splinters as debris was piled high into enormous heaps. There were 61 fatalities, and injuries to hundreds more. A total of 229 homes were destroyed and another 291 were damaged. In the Hilo area, 580 acres were inundated by the flooding water. The business district was covered by mud, peeled road pavement, twisted and collapsed buildings, and automobile hulks. Communication and transportation were shut down. The Waiakea area, where the hotels are today, was hit particularly hard.

Once again, the multi-ton boulders from the breakwater were brought in by the powerful waves and deposited on the downtown streets. The walls of water leveled city blocks. Infrastructure, including roads, sewers, and water mains, were mangled. Homes and businesses were moved off their foundations or swept away entirely.

The Hawai'i Redevelopment Agency was established by the Hawai'i County Board of Supervisors (now city council) eight days after the tsunami, with the aim of economic recovery. Hilo would have an inland greenbelt for parks and soccer fields and an attractive bayfront area. To instill confidence, state and county buildings were built on a berm overlooking the green buffer zone. The Small Business Administration provided low-cost loans to reactivate businesses, while homeowners were offered parcels of land to build well away from the inundation zone. Once again and with great diligence, Hilo would recover and prosper, emerging more resilient from the disaster.

ON R&R AT KILAUEA MILITARY CAMP. Charles Hansen, a young US Navy photographer, was stationed at NAS Barbers Point, Oahu, in 1960. He was on rest and recuperation, staying at the pictured military rest camp on the Big Island at the time of the tsunami. As a Navy photographer, he was allowed access to the stricken zone. His images, as well as those of others, provide a glimpse into the aftermath of the tsunami. (Charles Hansen Collection.)

A SHOP IN SHAMBLES. Charles Hansen and a friend had shopped in this store a day before the tsunami. The merchandise had been neatly stacked in rows. Rather than complaining, business owners began immediately to pick up the pieces of their businesses and their lives and begin again. (Charles Hansen Collection.)

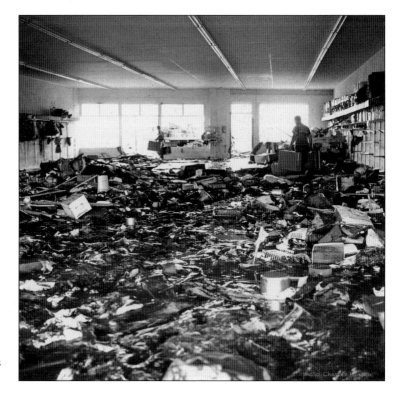

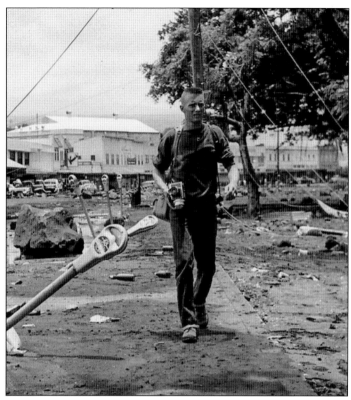

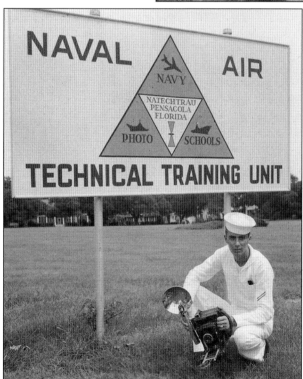

CHARLES HANSEN, PHOTOGRAPHER IN TRAINING. Charles Hansen received training at a Navy photography school in 1958. The training prepared him for his position as Navy photographer in Hawai'i, in which capacity he captured the images after the 1960 tsunami. (Charles Hansen Collection.)

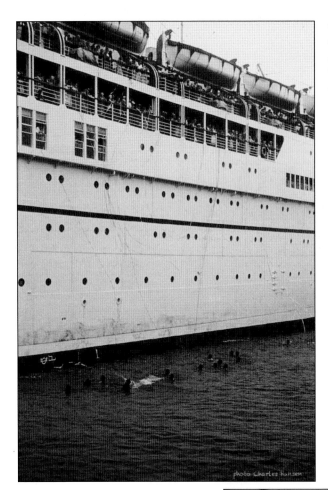

THE SAFETY OF DEEP WATER. The USS *Lurline* cruise ship put to sea earlier than scheduled because of the impending tsunami in 1960, and made it out safely. (Charles Hansen Collection.)

COIN TOSS. Just prior to departing from Hawai'i in May 1960, passengers tossed coins from the ship. The young local boys scrambled to collect them. (Charles Hansen Collection.)

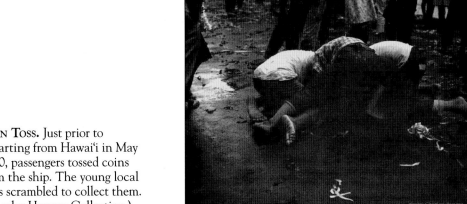

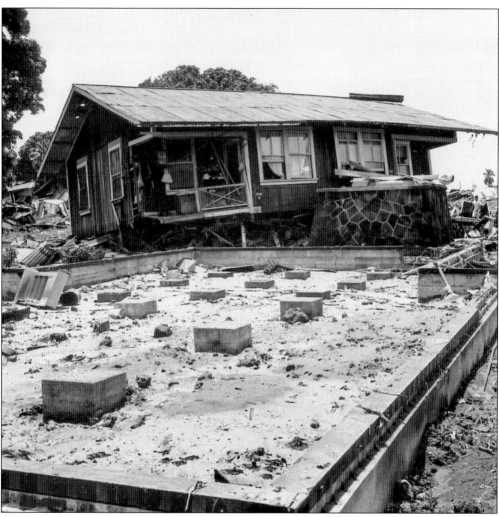

A Dream Premonition. At about 12:30 a.m. on May 23, 1960, Janet Fujimoto's family heard over the radio that three feet of water had inundated the Naniloa Hotel basement, and that this was probably the extent of the tsunami. The family decided to go to bed. Janet set her radio so that it would automatically turn off after 30 minutes; however, the radio shut off sooner, at about the same time that she heard a loud whoosh sound, followed by sharp crackling as short-circuiting occurred on Kamehameha Avenue. Janet had dreams on three occasions prior to this night in which a tsunami would prompt her to bring her parents to her room, situated in the middle of the house. Now Janet executed that plan in reality, saving her parents' lives. Seconds later, her parents' bedroom toppled over, and her father's carpentry equipment came right through the room. Janet said that everything was crashing and flooding from the bottom, with the house spinning. Then the house anchored on a stone wall, with water continuing to come in. The house was precariously tipped at about a 45-degree angle. Janet told her family to pray for their lives. Suddenly, the water powerfully receded, accompanied by strong suction. The family made it through the night with a candle, and were rescued in the morning. Although Janet has no photographs of the family home, this image provides an idea of what it might have looked like. (Charles Hansen Collection.)

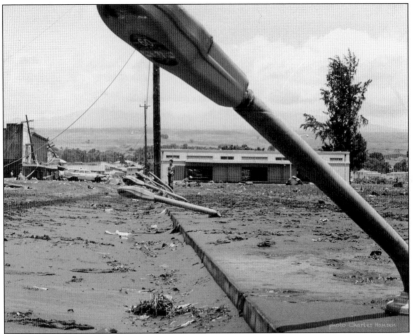

THE FORCE OF THE WAVES. The effects rendered by the force of the powerful waves were astounding. Hilo bayfront parking meters were bent to the ground (above). Transformers and electric cables were wrenched from utility poles (below). Concrete curbing was ripped out and carried inland. Entire city blocks were wiped clean. Structures, both wooden and concrete, were washed off their foundations and smashed into clusters of other buildings. Some buildings drifted offshore and broke apart at sea. Cars were stacked up into strange configurations and fishing vessels that had not been taken to sea were demolished. (Both, Charles Hansen Collection.)

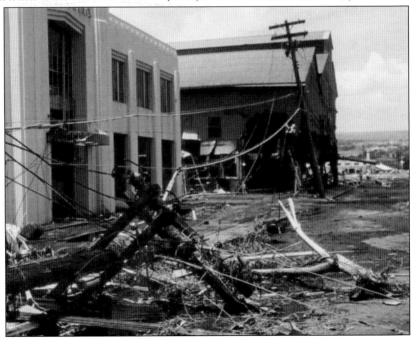

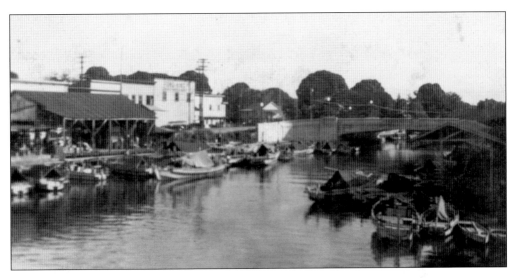

A Fishing Tale. The Suisan Fish Market by the Wailoa River survived the 1946 and 1960 tsunamis. In 1902, Kamezo Matsuno arrived in Hawai'i, staying in Waiakea's fishing village (above). He knew the fishing business but did not want to fish, so he took up fish peddling, driving his buggy door to door to sell fish. In time, a cooperative of peddlers and fishermen called Sui San Kabushiki Kaisha was formed. During World War II, fishermen of Japanese descent were not allowed to operate their fishing vessels, and Sui San Kabushiki Kaisha ceased operations. Just after the war, the devastating 1946 tsunami ravaged Hilo, and the shareholders had to rebuild and evolve. Kamezo's son Rex opened a frozen foods division, and the name of the company was shortened to Suisan. Then the 1960 tsunami struck, heavily damaging Suisan (below). Once again it was rebuilt, and it thrives today. (Above, Lance Abe Collection; below, Al Inouye Collection.)

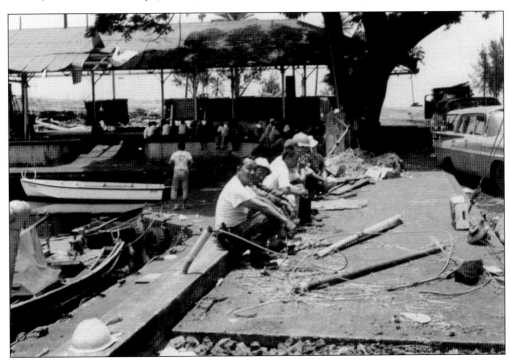

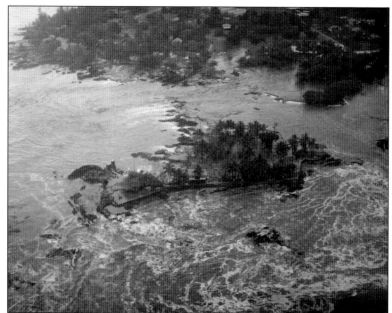

IDYLLIC WAY ON MOKU OLA ENDED IN 1960. Moku Ola, known today as Coconut Island, is a tiny island located just offshore of Waiakea. For two generations the Keli'ipio family members were its loving caretakers. Every member of the family had their duties. Paul Keli'ipio took over in 1947 after the 1946 tsunami churned over the island (above). He would row people back and forth between the island and shore for 5¢ each way. Hawaiians believed that a certain rock on the island possessed healing powers; the name "Moku Ola" means "healing island." In 1960, the Keli'ipios wisely evacuated when the tsunami warning was issued. That was fortunate because the waves scoured the island (below), and remnants of the Keli'ipio home were later found in Reed's Bay. The family lives in Keaukaha today, but they fondly remember the lifestyle on Moku Ola. (Above, James Kerschner Collection; below, Harry Kim Collection.)

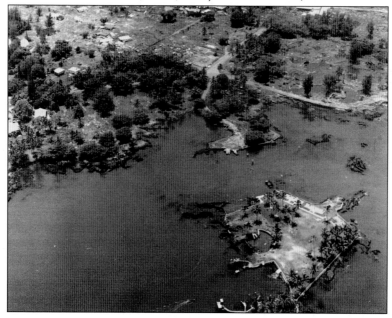

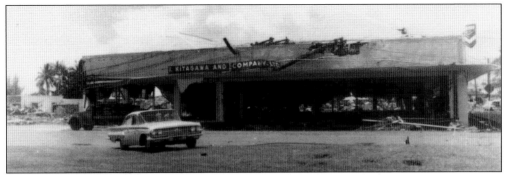

CAR DEALERSHIP DESTROYED. The Kitagawa and Company car dealership was destroyed by the tsunami in 1960. Every vehicle, piece of equipment, and the business records were swept into the Wailoa River, becoming debris. Even two large safes were found in the river. Interestingly, the safes were retrieved and are still in use. The company thrives today. (*Hawaii Tribune-Herald* Collection.)

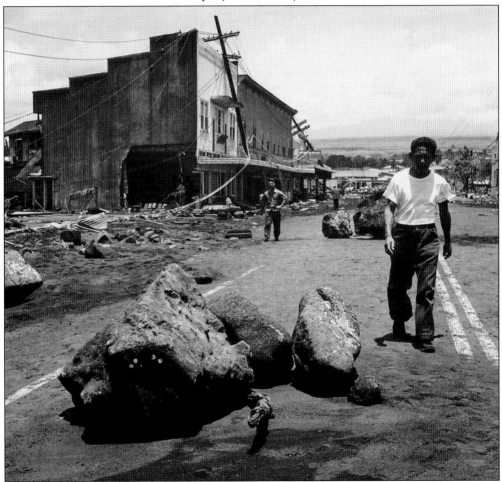

HUGE BOULDERS IN THE STREETS. Hilo's offshore breakwater was no match for the incredibly powerful tsunami waves. Huge boulders weighing as much as 22 tons were brought in like pebbles and deposited on shore. These boulders are in the middle of Kamehameha Avenue, with the Hobby House store in the background. (Charles Hansen Collection.)

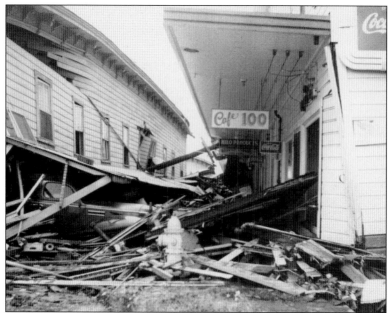

SAVED BY A CAFÉ IN 1960. Gloria Miyashiro Kobayashi's family business is Café 100, and Gloria is a very lucky lady. In 1946, she was still within her mother's womb when the tsunami struck. Gloria's pregnant mother could not run; fortunately, a strong stevedore carried her (and Gloria) to safety. The tsunami damaged the café (above), but the building was repaired and reopened. In time, Gloria's father wanted a larger café, so he built on land he had acquired across the street, constructing the residence behind the café. The grand opening was May 2, 1960 (below). Just three weeks later, the tsunami from Chile smashed into Hilo, devastating the new café. Fortunately, the café took the brunt of the impact and shielded the residence, saving the family. The café was again rebuilt and is open to this day, an example of the perseverance and resolve of the Hilo business community. (Above, Lawrence Nakagawa Collection; below, Gloria Kobayashi Collection.)

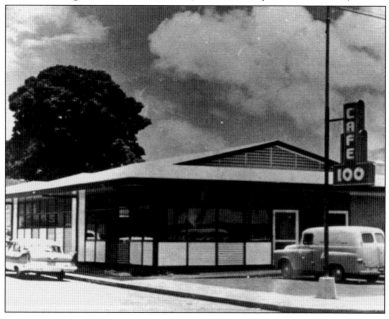

HAWAI'I JUNK: A TRUE TREASURE. Hawai'i Junk was a treasured family business formerly located at 224 Piopio Street. Seiji Aoyagi's father, Seisaku, left Japan and came to Hawai'i with an entrepreneurial spirit. In 1930, he started a business dealing in nonferrous metals (brass, copper, lead, zinc) and military surplus material from World War I, including items such as hats, blankets, raincoats, and custom-sized canvas. Additionally, he sold plants, pots, wooden barrels, and burlap sacks. At the time of World War II, Seiji was in high school, and his father was interned at Santa Fe, New Mexico. Before Seiji's father left, he said, "Just hang on because war does not go on forever. I'll be back." Seiji was drafted in 1945, the same year that his father returned to Hawai'i, ironically, on the same ship. When the 1946 tsunami hit, Hawai'i Junk was spared. In January 1947, Seisaku asked Seiji to join the scrap business, which Seiji agreed to do. When the 1960 tsunami came crashing ashore, waves washed through the Hawai'i Junk building, damaging and scattering the inventory. Thanks to the Hawai'i Redevelopment Agency, Hawai'i Junk was able to exchange its property for land at 10 Halekauila Street, and remained in business until 2005, when Seiji retired. (Seiji Aoyagi Collection.)

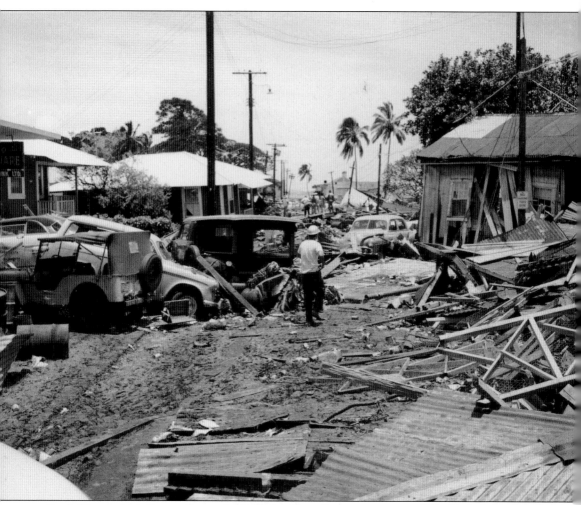

PAT'S HARROWING PIOPIO STORY. In 1960, Pat Carvalho was a junior at Hilo High School, and when she heard about a possible tsunami in Hilo, her reaction was typical: "It's not going to hit us." Pat's family heard the warning sirens on the evening of May 22 but did not pay much attention. At around 1:00 a.m. on May 23, Pat's father thought he would check to see if the water was rising, despite Pat's pleas not to go. He did not even reach Hawai'i Junk, right in front of their home on Piopio Street, when the power plant exploded. He ran back to the house, up the stairs, and told the family that they did not have a chance. He said, "If we're going to go, we're going to go together." Huddling and praying together in the hallway, they could hear water coming in under the house and things crashing. Then, in the darkness, the family heard Pat's uncle calling them. It was difficult to open the door because of the water, but once it was opened they formed a human chain and walked down the stairway into neck-high water. Through the debris, they made their way up Piopio Street to safety. The hardest part was hearing babies crying. (E. Lynn Guenther Collection.)

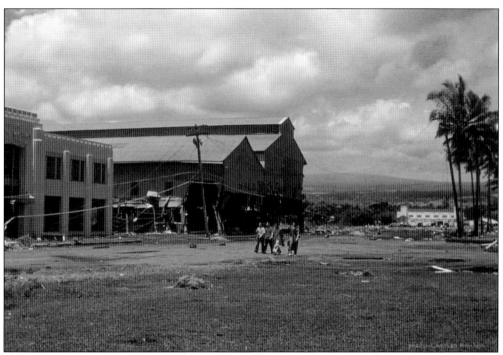

PARCELS WIPED CLEAN. Badly damaged Hilo Iron Works is at center. Prior to the tsunami, a print shop occupied the building on the far right. The parcels in between had been the sites of Hawai'i Planing Mill, a used car dealership, and Schuman Equipment Company. (Charles Hansen Collection.)

AERIAL VIEW OF WAIAKEA TOWN. The Waiakea Town part of Hilo was once a thriving area that was home to thousands of residents and 40 businesses. It was devastated by the 1960 tsunami. This image shows Reed's Bay (lower left), private homes (lower right), the generating plant, and Waiakea School (center left). Today, the Waiakea area has only a golf course, park, and hotels with tsunami-resilient construction. (*Hawaii Tribune-Herald* Collection.)

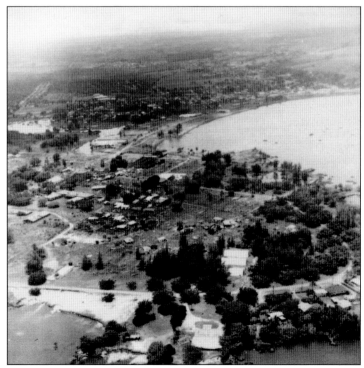

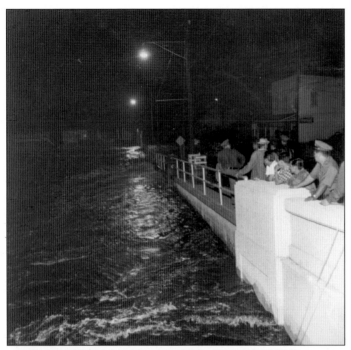

LUCKY BOYS. The Waltjen brothers were waiting and watching for tsunami waves with others on the Wailoa Bridge on the night of May 22, 1960 (left). Disobeying their parents' orders, curiosity motivated their behavior. As the water began to recede, the boys attempted to prevent a boat from being washed away (below). They were completely unaware of what was coming—a wall of water twice as high as the Wailoa Bridge, heading directly toward them. While others on the bridge did not survive, the Waltjen brothers were lucky. (Both, *Hawaii Tribune-Herald* Collection.)

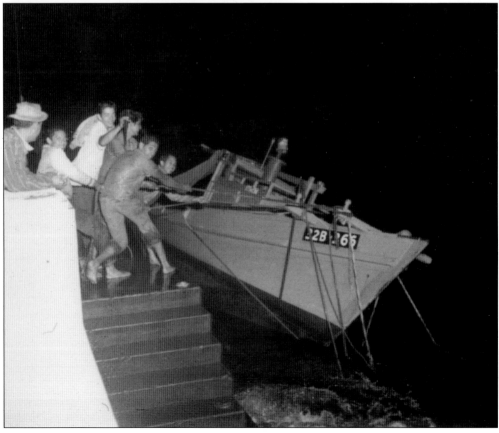

HILO SODA WORKS, PART ONE. As a youth, Edward "Ed" Shindo's family lived at 397 Piopio Street, where Ed's father began his own company, Hilo Soda Works (above). As was common, the family lived upstairs, with the business downstairs. There was plenty of work for the family, such as washing the bottles and bottling the flavored sodas that Ed's father delivered with his Model T truck. Even though there were chores to do, there was time for the children to enjoy being children. They ate the luscious fruits on the trees, swam in the Wailoa River, and played games. Life was idyllic on Piopio Street, and everyone lived in harmony. After graduating from high school, Ed became an auto mechanic at Hilo Motors, but a year later he went back to the Soda Works, working there until he retired in 1994. (Edward Shindo Collection.)

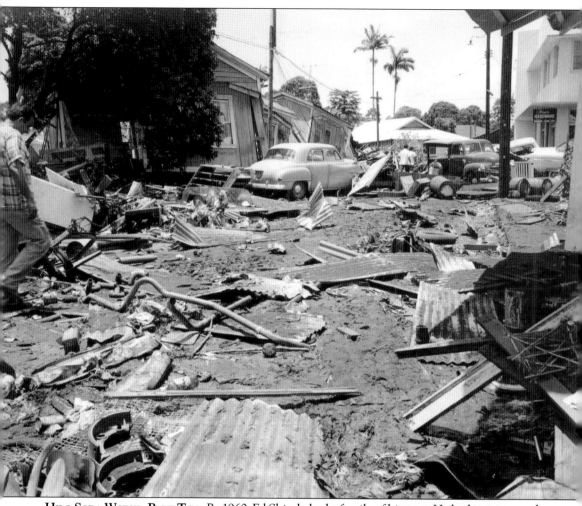

Hilo Soda Works, Part Two. By 1960, Ed Shindo had a family of his own. He had just returned from a beach outing with his son when a neighbor told him, "Hey, there's a tidal wave warning but most likely going to be another false alarm." Luckily, the Shindos evacuated. Before leaving, Ed said, "Even though we didn't really believe, we did put everything, like the washing machine, up on blocks." The waves did not come, and "Between 12 midnight and 12:30 a.m. we figured that with work the next day, we should go home." On the way home, Ed parked the car on Kilauea Street where Tsuda's Service Station used to be, with his family sleepily waiting in the car, and talked to the policeman on duty. Just then they saw a wave hit the break wall and go straight up. As it surged in, everything seemed to explode. The electrical transformers sounded like cannons as they were hit. Ed ran for the car and took the family to safety. The next morning, Ed found that one wall and the partition between the living room and dining room were all that remained of his home on Piopio Street. This photograph shows the extensive damage along this street. A stack of unbroken dishes, lodged under the linoleum, was salvaged from the home. Hilo Soda Works was not seriously damaged; nonetheless, it was relocated to Kawili Street in the industrial area through the Hilo Redevelopment Agency. At the same time, Hilo Soda Works received the Pepsi Cola franchise, building it into a real success. Then, in 1996, both the Hilo and Honolulu operations were bought out, thus ending the Shindo family's Hilo Soda Works. (E. Lynn Guenther Collection.)

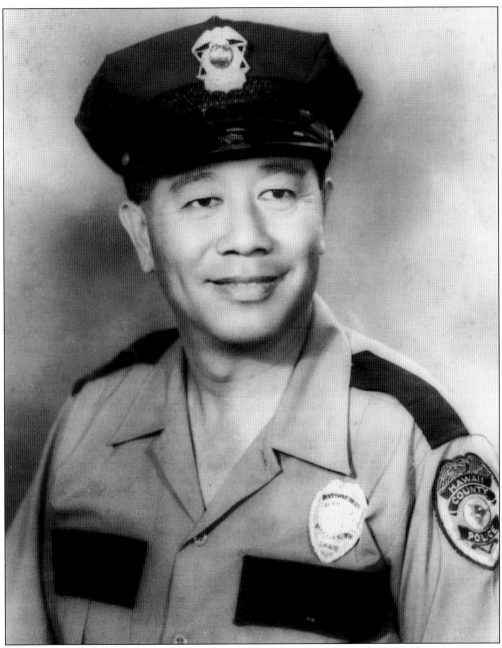

STEAMY CHOW STILL ON DUTY. Steamy was still on the police force in 1960. After the tsunami warning was issued, he was assigned to give evacuation order announcements along the Keaukaha coastline. The first wave was expected to hit at 10:30 p.m. Midnight arrived and Hilo Bay was still flat. This was an old, too-familiar scenario. Many people either did not bother to evacuate or had already returned to their homes. Then, just minutes after 1:00 a.m., Steamy saw the night sky light up with a blue flash, followed by the whole town going dark. Chaos ensued as people fled and buildings splintered apart. In the course of the awful night, a rumor spread that a police officer had perished, and Steamy's wife was concerned that it was her husband. She was relieved to find Steamy alive and well the next day. (Bob Chow Collection.)

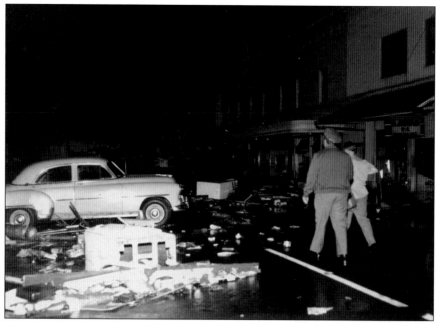

POLICE PATROL. Sgt. Teruo Morigaki had been on patrol evacuating coastal areas after the tsunami warning was issued in 1960. Officers on foot were stationed at key intersections to prevent people from returning (above and below). But some people had not evacuated, and after the first wave washed inland, people poured from their homes. Sergeant Morigaki shouted for people to jump into his patrol car, and the packed car made its way to higher ground. After unloading, the sergeant returned to the disaster area to see who else he could help. He looked into collapsed buildings and sought out the injured. One of his main impressions from the tsunami was how the community pulled together, protected each other, and faced adversity with resilience and tenacity. (Above, Howard Pierce Collection; below, *Hawaii Tribune-Herald* Collection.)

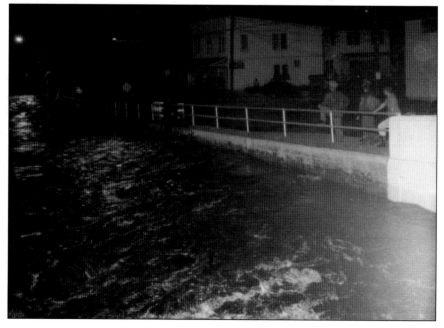

Wiped Clean to the Foundation. After the 1946 tsunami, Hawai'i Planing Mill (HPM) was rebuilt across the street from its original location as a reinforced steel structure. However, the 1960 tsunami struck with such ferocity that then-president Robert Fujimoto was astounded at what he saw. "I could see where our building was supposed to be . . . There was nothing there. I couldn't imagine that the tsunami would have taken it, the whole building, because it was one of the first all-steel buildings." (Robert Fujimoto Collection.)

Bolts Stripped. "The building sat on a concrete pier, with bolts on it. What happened was a wave must have pulled the building up. All the bolts were stripped." The twisted, battered pieces of the structure were in the Wailoa River. Fortunately, Robert Fujimoto had removed all of the important documents before the tsunami hit. With help from its employees and federal, state, and county programs, HPM recovered, resumed business in a short time, and thrives today. (Robert Fujimoto Collection.)

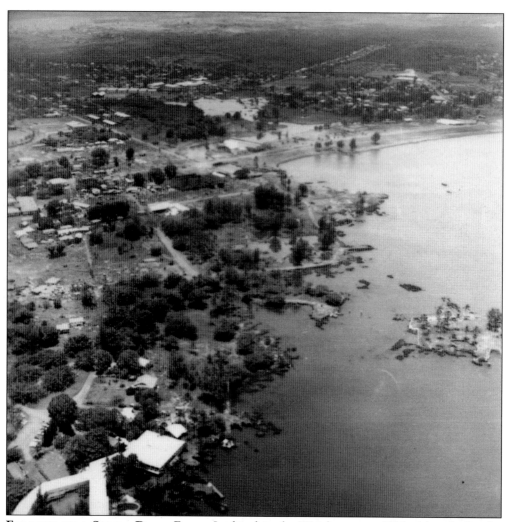

Floating on a Screen Door. Fusayo Ito lived in the Waiakea area of Hilo (above). On the afternoon of May 22, she heard that an earthquake in Chile had generated a tsunami that would arrive at about midnight. Fusayo thought she was safe in her area, and when 1:00 a.m. arrived without event, she figured nothing was going to happen. Soon after, she heard a deafening sound as the gigantic third wave came crashing in, destroying her house and knocking her unconscious. When she came to she found herself in the Wailoa River on her screen door; eventually she was washed out to sea, drifting farther and farther out. Once past the breakwater, she thought her life was over, and made her peace. Luckily, a pilot spotted her and alerted the Coast Guard to investigate. After being rescued, her first reaction was to hug everyone she met. Another miracle was to unfold. Through the years, Fusayo had purchased savings bonds for her daughter, which she kept in a pouch at her home. The pouch was lost, along with her home. Months later, a bulldozer operator saw the pouch on the ground. He turned it in to police, who called Fusayo. Fusayo wanted to give back to the community after her ordeal, and she volunteered for many organizations, including the museum. (*Hawaii Tribune-Herald* Collection.)

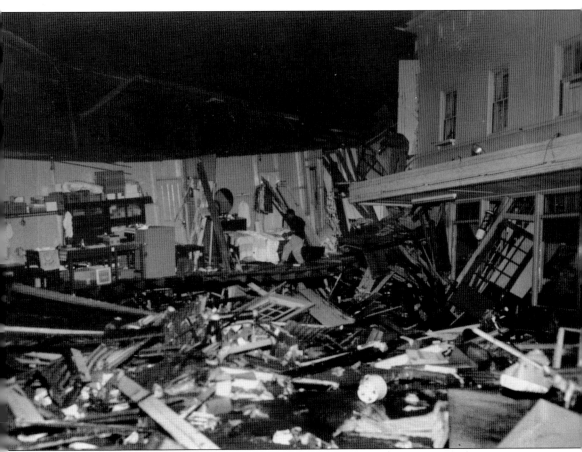

MAMO STREET MESS. In 1960, buildings crashed into other buildings on Mamo Street, where the Chicken Store was located. Although the store survived the 1946 tsunami relatively unscathed, and it was repaired and reopened, the 1960 tsunami completely destroyed the building. Laura Yuen Chock, daughter of the Chicken Store owners, said, "It was something you never hope to see again. Everything was pushed up to Kilauea Avenue. Mamo Street up to Keawe Street was all gone." It was necessary to employ cranes to lift buildings in the search for victims and survivors and to clear the rubble. Mamo Theater is on the right in this photograph. (Howard Pierce Collection.)

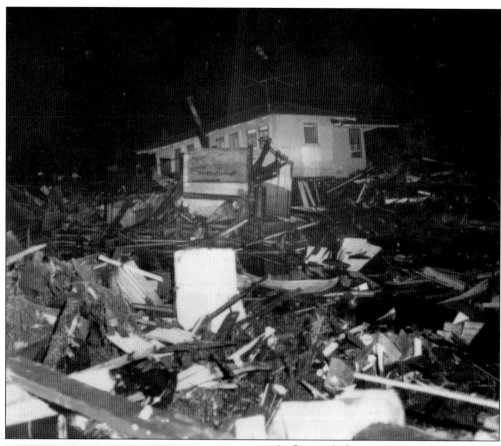

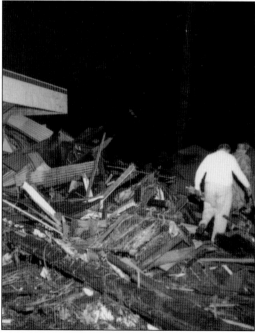

AL INOUYE'S STORY, 1960. Al was 18 when the 1960 tsunami struck. Like many others, he was with friends on the Wailoa Bridge. When the huge wall of brown water came in, people ran for their lives as power pole lines whipped about in the water. Drivers were barreling up the street trying to escape. Al wondered if he would die by drowning, electrocution, or a fast-moving car. With the power out, he and his friends parked their cars so that the headlights would assist people trying to find their way to safety (above and left). Morning light revealed a flattened Hilo landscape. Interestingly, Al survived three tsunamis in his lifetime. In 1946, Al's father brought his family to the Coca-Cola plant for safe refuge. Al's father also rescued a young girl, making her a garment made of burlap. In 1975, Al's family was staying at a beach home in Kapoho when the locally generated tsunami struck. (Both, *Hawaii Tribune-Herald* Collection.)

AN EXPANSE OF RUINS. Damage was widespread in Hilo after the 1960 tsunami (right and below). The photograph at right shows the remains of the Boys Club of Hilo on Kamehameha Avenue, with the Hilo Theater to the right of it. The Boys Club began in 1952, originally open only to boys. That policy changed in 1988 when girls were allowed to join, and the name was changed to the Boys and Girls Club. After the tsunami, the building was razed, and soccer fields occupy the site today. The club was relocated to Kamakahonu Street in Hilo where it stands today; it has serviced over 50,000 youth since its inception. (Both, *Hawaii Tribune-Herald* Collection.)

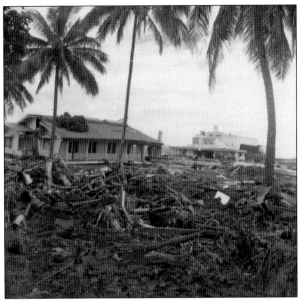

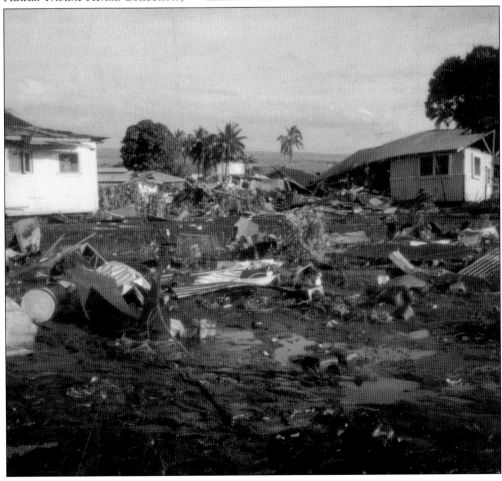

WADING AND WATCHING. In 1960, people were naturally curious and watching to see what would happen (left). Others waded in the water trying to determine what to do or perhaps fishing (below). The price of complacency, confusion, and misunderstanding was the loss of 61 lives. (Both, *Hawaii Tribune-Herald* Collection.)

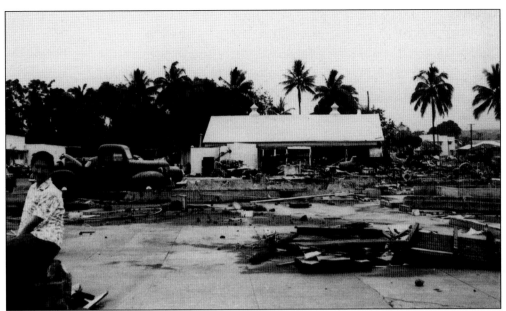

GOYA BUSINESS STORY, PART ONE. The Goya family owned and operated Goya Brothers Service Station, May's Fountain, and Ellen's Liquors at the corner of Bishop Street and Kamehameha Avenue. According to survivors, the tsunami crashed onshore with a roaring sound accompanied by ripping metal and booming electrical transformers. Afterward, all that remained of the service station was a flat cement slab that looked freshly poured, the oil and grease scoured off by the waves (above). The black truck in the above photograph was driven to the site from elsewhere, and was parked in the spot where the King Kamehameha statue would be built in the 1990s. The Excelsior Dairy is seen in the center background and Dairyman's is the building at far left. Below, Goya's debris was pushed up against Dairyman's. The direction of the tsunami waves was from the right. (Both, May Goya Collection.)

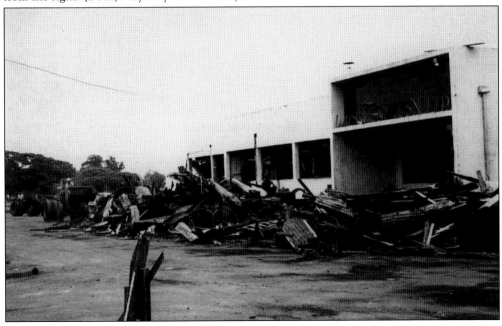

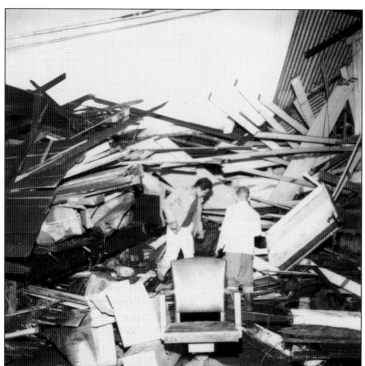

GOYA BUSINESS STORY, PART TWO. The Goya buildings and contents were gone. The company safe was found on bayfront near the Iron Works building; the money was dried and ironed in order to save it. The Goya family observed 20-foot-high piles of debris (left) in Hilo, an incredible sight never to be forgotten. They saw liquor bottles that had never been opened but had sand inside. The force of moving water is amazing. (*Hawaii Tribune-Herald* Collection.)

MAY'S LIQUOR AND LUNCH SHOP. Although the Goya business was destroyed for the time being, May's Liquor and Lunch Shop at 52 Ponahawai Street opened soon after the tsunami, another testament to the resilience and tenacity of the Hilo community. These survivors, like others, will always remember those who perished in the tsunami. (May Goya Collection.)

WAIAKEA CLOCK STORY, PART ONE.
For years, Takayoshi Kanda has been the caretaker of the Waiakea Clock Memorial (right), located in the area that used to be Waiakea Town. Takayoshi grew up in Waiakea and resided there with his own family in 1960. He joined his buddies down at the Suisan Fish Market (below) to watch for the waves on the evening of May 22. Fortunately, they ran to higher ground when they saw the water recede. But Takayoshi was worried about his parents in his childhood home on Kainehe Street, so he sent his daughter and son-in-law to get them. They were all ready to leave in the car, but his father went back into the house to get something. A wave struck, carrying the house, with his father inside, onto the street. He could not be found until two days later, when the house was demolished. (Right, author's collection; below, James Hamasaki Collection.)

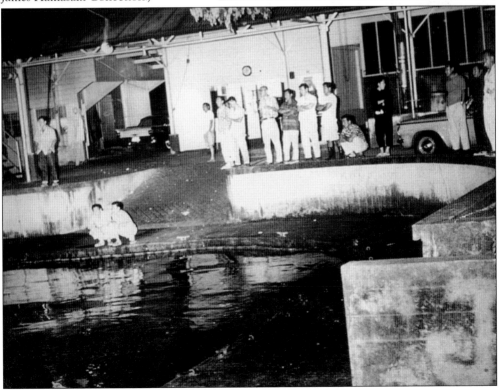

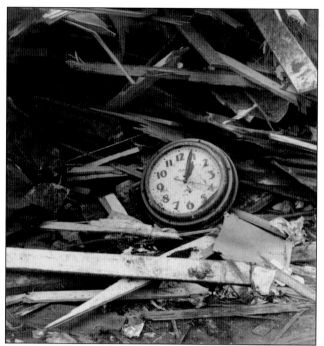

WAIAKEA CLOCK STORY, PART TWO. The 35-foot third wave struck at 1:04 a.m., and the clock was frozen in time at that hour (left). The clock was salvaged from the rubble, and to this day, Takayoshi Kanda maintains the Clock Memorial site in memory of his father and the other tsunami victims. He purchases flowers for the memorial himself (below), and has a very practical philosophy. First, always put two bouquets there; one would be lonesome. Second, place extra flowers there on holidays. Third, the most likely flowers to be stolen are chrysanthemums. Fourth, put anthuriums there; they are the least likely to be stolen. (Left, *Hawaii Tribune-Herald* Collection; below, author's collection.)

WAIAKEA KAI SCHOOL. Waiakea was an idyllic community in the Hilo area. The area was hard-hit by the 1960 tsunami, as a reflected wave impacted the peninsula. This photograph shows the school in 1957; it was heavily damaged by the tsunami in 1960. (Howard Pierce Collection.)

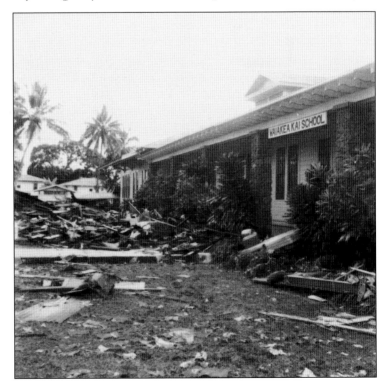

WAIAKEA KAI SCHOOL AFTER 1960 TSUNAMI. This photograph shows the damage to the school, surrounded by debris. (*Hawaii Tribune-Herald* Collection.)

KTA Waiakea Store. The original K. Taniguchi Shoten was on Lihiwai Street across from Suisan Fish Market in Waiakea. The KTA philosophy to give back to the community stemmed from those early days. The family lived upstairs, and the store, which sold produce and canned goods, was downstairs. Interestingly, there were two stores in Hilo that had the letters "K" and "T" in the name, and this produced shipping mix-ups. To ameliorate this problem, the first letter of the alphabet was added to KT, and that is how the name KTA came to be. (Barry Taniguchi Collection.)

KTA Downtown Store. Through diligence, KTA was able to open a branch store on Keawe Street just before World War II, when business was bustling downtown. (Barry Taniguchi Collection.)

DESTRUCTION OF KTA WAIAKEA STORE AND EXPANSION OF DOWNTOWN STORE. The 1946 tsunami destroyed the store with the upstairs residence in Waiakea. But the Keawe Street store was not damaged, and it was expanded. In fact, in 1953, a butcher department and dry goods section (above) were added, and in 1956, the island's first self-service meat department (below) was made available to customers. The 1960 tsunami damaged the Keawe location. The store flooded to about four feet, ruining merchandise on the first floor. But the goods on the second floor were fine. The store reopened in two weeks. In the ensuing decades, KTA continued to grow in terms of branches and innovations, with many firsts, such as first in-store bakery and first supermarket in the state with UPC barcode scanners at all checkouts. (Both, Barry Taniguchi Collection.)

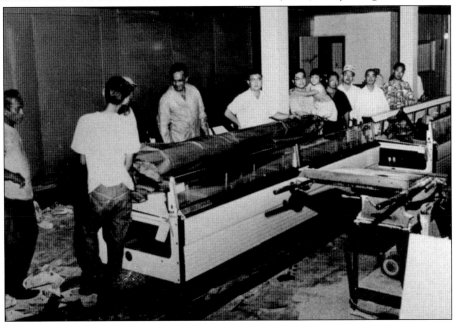

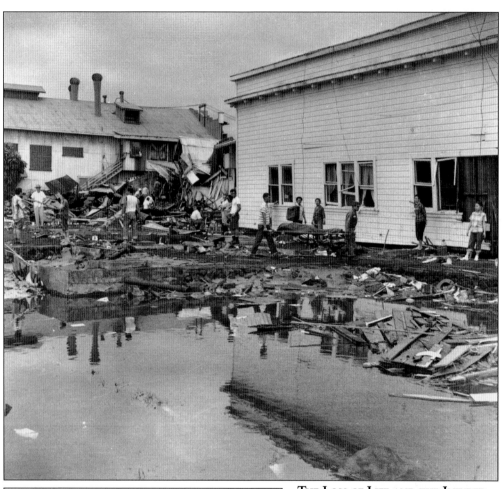

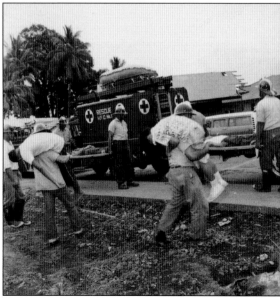

THE LOSS OF LIFE AND THE INJURED. The 1960 tsunami caused 61 deaths, all in Hilo. Although there was a warning system, a change in the siren protocol resulted in some confusion about the need to evacuate. The relatively small tsunamis of the 1950s had engendered a sense of complacency, a feeling that this tsunami would just be another minor event. Other people were curious, misinformed, or in the wrong place at the wrong time. Numerous individuals required medical care for lacerations, contusions, and bacterial infections from the tainted water. Above, a fatality is carried on a stretcher, and at left, injured individuals are assisted by first responders. (Both, *Hawaii Tribune-Herald* Collection.)

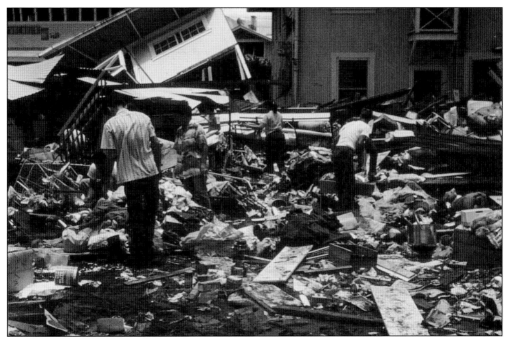

THE MONETARY LOSS. Over 150 businesses were damaged or destroyed. Hundreds of homes were affected. The total loss was estimated to be $50 million in 1960 dollars, a huge sum at the time. About a third of the labor force was affected in some way. Businesspeople got to the task of cleaning up. Many businesses were gone altogether, while others were gutted, as if all the contents had been sucked out. Merchandise was scattered and swept out to sea. Workers, students, and other volunteers all pitched in to help in the cleanup efforts. (Above, Charles Hansen Collection; below, *Hawaii Tribune-Herald* Collection.)

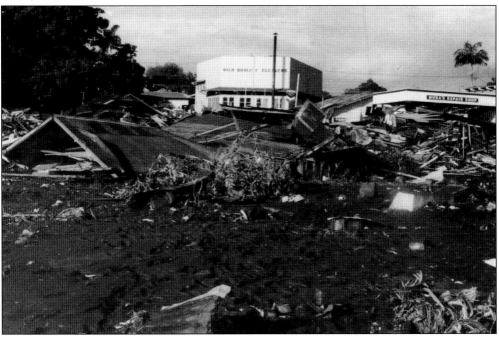

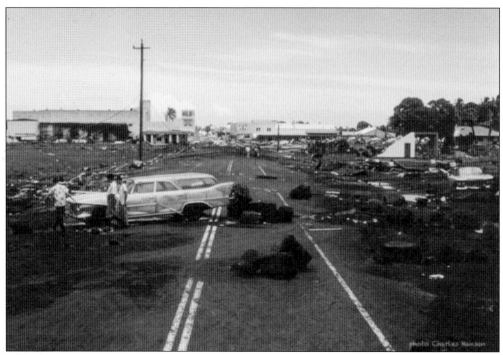

NEW CAR. A new vehicle was washed from an auto showroom as a result of the tsunami. The Hilo theater is visible, as well as boulders in the street. (Charles Hansen Collection.)

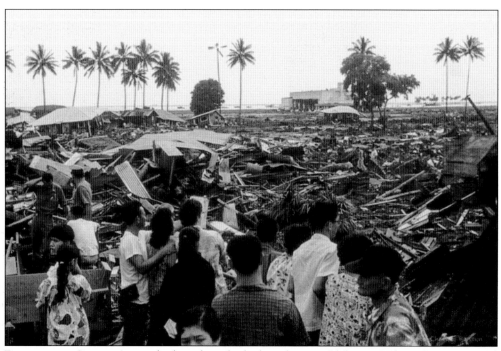

RESIDENTS IN SHOCK. Astonished residents looked on the sea of debris in Hilo with concern and anguish, as officials looked for the missing. (Charles Hansen Collection.)

DESOLATE PARK.
Liliuokalani Gardens
in the Waiakea area
of Hilo near Coconut
Island was named
in honor of Queen
Liliuokalani. A
Japanese tea garden,
it features oriental
bridges, lanterns,
and footpaths. After
the tsunami, it was
strewn with debris.
(*Hawaii Tribune-
Herald* Collection.)

PARK TODAY. Today Liliuokalani Gardens is a lovely place for a stroll with its bridges, ornamental objects, waterways, ocean views, and paths. Residents and visitors enjoy recreation at the park. They swim, picnic, and look for shells at nearby Coconut Island. (Author's collection.)

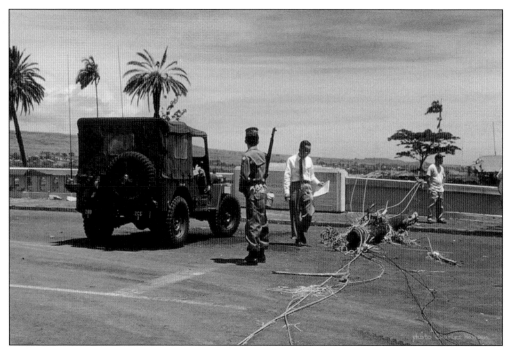

FIRST RESPONDERS. The first responders to the tsunami disaster protected life and property and dealt with the death and destruction left behind by the waves. First responders included police, firemen, National Guard, Red Cross, morticians, volunteers, Boy Scouts, newspaper reporters, and others. In this photograph, a National Guard presence was set up to restrict entry to affected areas. In addition, officials compiled damage reports. (Charles Hansen Collection.)

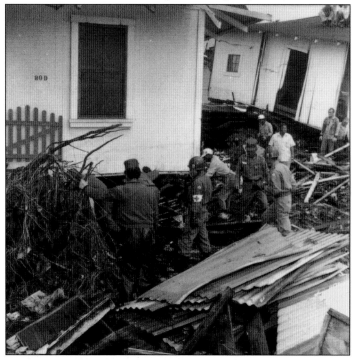

A COMMUNITY EFFORT. Civil defense and civilian first responders search under a destroyed home. It was a grim task to look for the missing. (*Hawaii Tribune-Herald* Collection.)

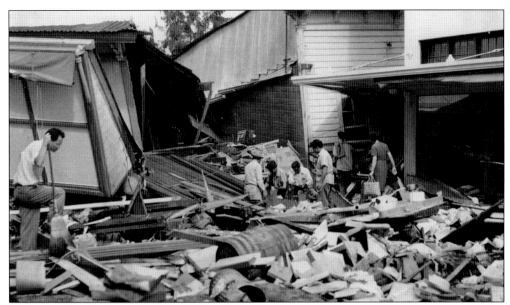

KAIKO'O PROJECT, PART ONE. After the 1946 tsunami, some businesses and homes were rebuilt in areas that could be hit again, like Waiakea and Shinmachi. After the 1960 tsunami, it was apparent that vulnerable, low-lying areas are not suitable for construction. The Hawai'i Redevelopment Agency was organized eight days after the 1960 tsunami to coordinate the efforts of federal and state agencies to get Hilo back on its feet. The shoreline buffer zone that had been established after the 1946 tsunami was expanded to include a 300-acre greenbelt of lawns, lagoons, and gardens. A 40-acre elevated plateau was built at the edge of the 1960 high water mark. Landfill raised the berm 26 feet above sea level. To instill confidence, in 1963, the county built its $1.7 million headquarters on this site, followed by the state's $2.5 million headquarters. Kaiko'o Mall was erected, which included major chain stores and local merchants. (Morris Lai USAAF Collection.)

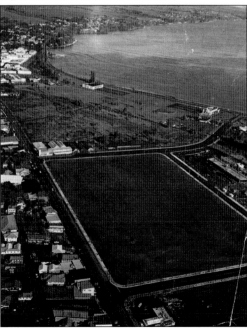

KAIKO'O PROJECT, PART TWO. This project was called "Kaiko'o," which means "rough seas" in Hawaiian. Funds from both the federal and state government were made available for housing assistance, and the Small Business Administration provided low-cost loans to get businesses operating again. Hilo would rebound and thrive, and the tenacity of Hilo residents was apparent. The Kaiko'o project had provided new economic opportunity, a safe buffer zone, and an attractive bayfront. This 1960s photograph shows the vacant area where Kaiko'o Mall was built. (Charlotte Corella Collection.)

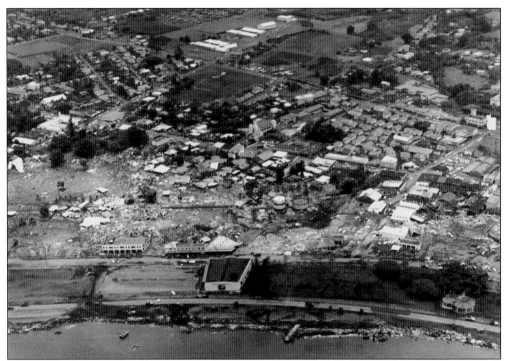

1960 Hilo Bayfront. This aerial view of downtown Hilo following the May 23 tsunami starkly reveals the extent of destruction. Buildings were completely washed away or pushed into other buildings. Note the bandstand in Mo'oheau Park at lower right. (Harry Kim Collection.)

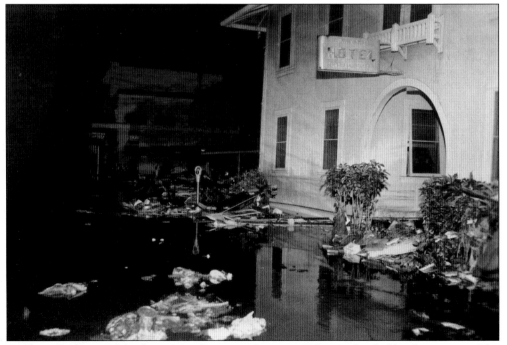

Flooded Streets. Like other streets, Furneaux Street in Hilo was flooded by the tsunami. The building to the right is the Pualani Hotel. (Howard Pierce Collection.)

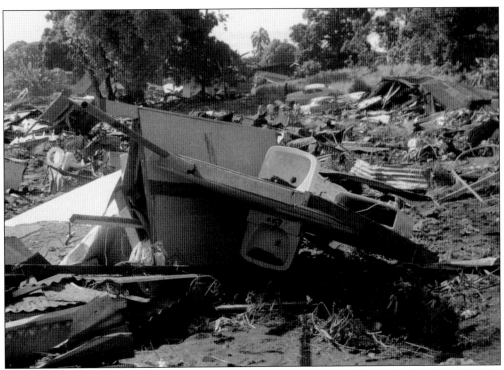

SINKS. Debris ended up in odd configurations. Here, sinks are still attached to the wall of a lavatory that had been totally destroyed. (Howard Pierce Collection.)

DEATH TOLL. The final death count, determined many days after the tsunami hit, was 61. Gas masks were needed for bodies recovered days after the tsunami. Although there was a warning system, the numerous warnings, evacuations, and relatively small tsunamis of the 1950s had resulted in complacency and misunderstanding among the citizenry. (*Hawaii Tribune-Herald* Collection.)

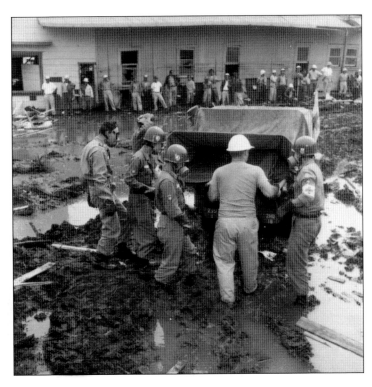

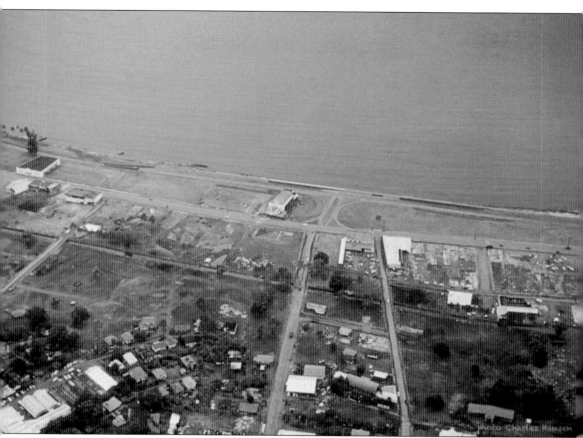

AERIAL VIEW, SIX MONTHS LATER. Recovery help from volunteers was tremendous. County and state crews were assisted by the sugar plantations, which donated use of heavy equipment. A large union donated members' work time to operate the heavy equipment. There was help from the armed forces, private business, Boy Scouts, and civic groups. Gov. William F. Quinn called an emergency session of the Hawai'i state legislature. Key legislation was enacted enabling the county to enter into a federally assisted urban renewal project in the disaster area, public lands were made available to relocate families and businesses, funds were made available for public housing units, and a program of commercial loans and unemployment benefits was set up for disaster victims. The idea was to move the businesses and people and revitalize the area to minimize impact from future tsunamis. (Charles Hansen Collection.)

Five

LOCALLY GENERATED TSUNAMIS

Most tsunamis are generated by seafloor movement displacing a large volume of water, accompanied by a large earthquake. Waves are initiated at the source of the disturbance and can travel vast distances through the ocean. However, some geological events trigger tsunamis locally. That is, the event originates close to home. The triggering event can be a local earthquake, landslides, volcanic activity, or underwater seamount crater collapse, all possibilities for Hawai'i.

A local earthquake occurred in 1868, triggering a landslide in Wood Valley on Mauna Loa's slopes on the Big Island. Over 30 islanders and numerous animals were buried in the slide. A tsunami was generated that obliterated villages.

Two local earthquakes occurred in 1975 in the same vicinity, caused by the sudden movement of the seafloor off the southeast coast of Hawai'i. The shoreline terrain subsided up to 10 feet, submerging palm trees. It was Thanksgiving weekend, and fishermen, a Boy Scout troop, and others had hiked down to Halape. There were two fatalities, and homes were damaged in Punalu'u, 20 miles away.

Landslides are part of the normal growth and aging process of volcanic islands. They can be of two kinds. Slumping landslides are often thick and slow, and can result from a geological adjustment. Slumps move on an overall slope greater than three degrees, and involve mass movement of land. The Hilina slump off the south coast of Hawai'i produced a rapid adjustment in 1975 and perhaps in 1868. Debris avalanches are typically longer, thinner, faster, and move on an overall slope less than three degrees, producing fragmentation of the original structure.

The birth of volcanic islands may pose a tsunami threat as well. In 1919, Mauna Loa erupted, pouring large volumes of lava into the sea, causing a tsunami. Today, there is an active volcanic underwater volcano, Loihi, destined to become our next Hawaiian island—in 10,000 to 100,000 years. Landslides and earthquakes are frequent on Loihi. In 1996, the summit collapsed as the underlying plumbing structure changed. Accompanying the collapse, two submarine landslides and 4,000 small earthquakes occurred over several weeks' time. Fortunately, the earthquakes were small, and no tsunami was generated. Had a large earthquake occurred, a tsunami could have been generated.

A locally generated tsunami comes ashore quickly. If you are near the coast and feel a strong earthquake or observe receding or abnormally high water, move inland and uphill immediately.

Riveting Camping Tale Part One. John Kalani and his family, avid campers, spent Thanksgiving weekend in 1975 at the beach at Punalu'u. John deployed lobster nets and set up camp. The family slept on cots in a pavilion. The first earthquake struck at about 4:00 a.m., but John did not feel it. When the second one struck at about 4:45 a.m., he stood up but could not maintain his balance. John's father observed that the water level was low. As John and his wife went to the bathroom pavilion, they saw John's sister and niece scrambling, being pulled by the receding water. The niece was overcome, but John jumped in and yanked her out of the water. The family members ran to their cars. Another niece was missing. John took a gas lantern down to the beach to look for her. He saw the tent in a bundle, and using a pocketknife, cut a hole in the canvas to see if she was inside. Then he heard a gravelly noise, rocks turning, and knew a wave was coming. Unable to locate the niece, he took the rest of the family to the car. They could not cross a dip in the road because a wave had already inundated the area. An ominous crackling noise in the coconut grove was the sound of a house being splintered. Abandoning the car, they scrambled up a hill. (John Kalani Collection.)

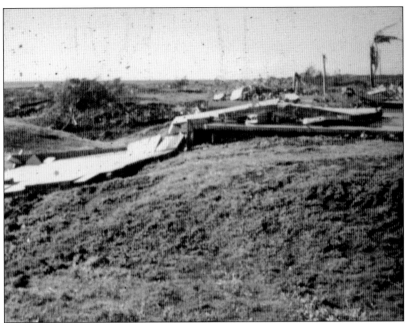

RIVETING CAMPING TALE PART TWO. In the morning, John and his family returned to their campsite for their belongings. They were incredulous to see that everything was flat (above). Only the big pavilion on the hill remained at the beach park; the other two pavilions were gone, only their concrete slabs left. Houses were flattened or heavily damaged. The house shown below belonged to an old man named Kyota Ito. The house was lifted by a wave and wrapped around a coconut tree. Ito survived and was found sitting at his kitchen table. John Kalani's family lost their possessions, but everyone survived. Fortunately, the missing niece had made it to safety in a different car. John's suggestion is that if you feel an earthquake near the ocean shoreline, "get a good head count of everybody around you . . . and get away from low land." (Both, John Kalani Collection.)

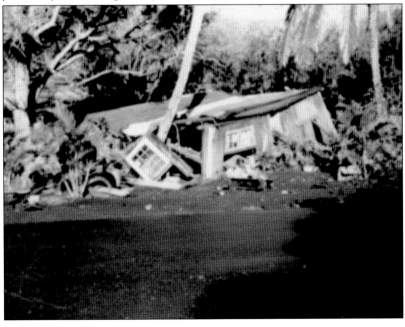

TRAGEDY AT HALAPE. Over Thanksgiving weekend in 1975, Boy Scout Troop 77 hiked to Halape by the ocean in Hawai'i Volcanoes National Park. Five of the boys decided to camp a half mile south at Boulder Bay, where a new shelter had been built. Four adults and one scout remained at Halape. On November 29, 1975, Michael Stearns and the others at Boulder Bay were awakened by a 5.7-magnitude earthquake, followed by one of 7.2 magnitude. Fearing that boulders would crash down the hillside, the Scouts crouched behind a three-foot wall on the ocean side. Michael scrambled to escape the wall of water submerging Boulder Bay. He clung onto a post as the tsunami shoved him and the shelter to the back of the bay. Suddenly he felt a jolt against his head, and his head throbbed and bled. The second wave was even bigger, slamming him against lava, bushes, and the shelter repeatedly. Michael felt the wave receding, dragging him out to sea. He groped for something, anything that could save him, and managed to get to higher ground, albeit without shoes or glasses. Before daybreak, the group reached the one-mile mark to Halape, where they sat shivering in the piercing wind, waiting for the sun to come up. At dawn, a small plane spotted them and a rescue was enacted. In the end, the Boy Scout leader, Dr. Mitchell, as well as a local fisherman, died in the event. (Dorothy H. Thompson Collection.)

HALAPE PRIOR TO 1975 TSUNAMI. This photograph shows the trail leading down to Halape. Note the coconut grove on dry land to the right. (Chris Hirayama Collection.)

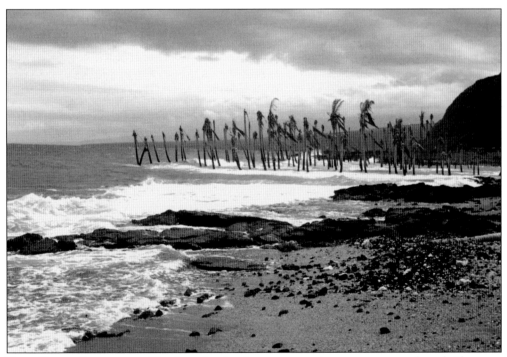

PALM GROVE SUBMERGED. The inundated palm tree grove is a testament to the subsidence at Halape after the 1975 earthquake and tsunami. The shoreline terrain dropped up to 10 feet. (Chris Hirayama Collection.)

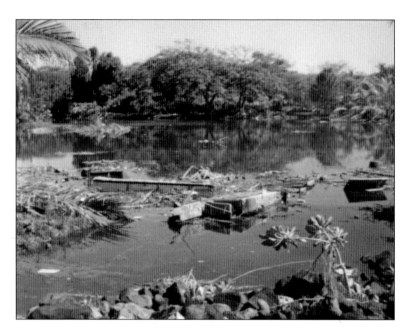

DEBRIS IN POND. Lumber and other materials ended up in the pond at Punalu'u Beach in Ka'u after the 1975 tsunami. (John Kalani Collection.)

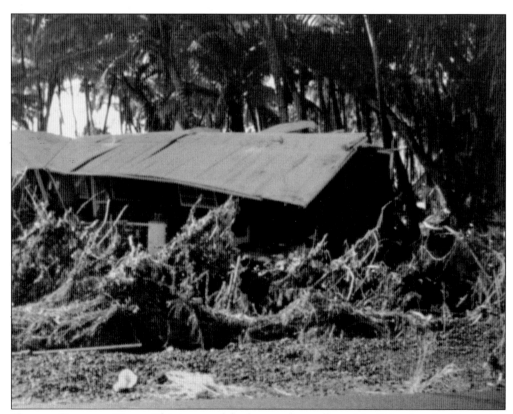

HEAVILY DAMAGED HOME. This is one of the homes that collapsed in Ka'u after the November 29, 1975, locally generated tsunami on the Big Island. (John Kalani Collection.)

BIG ISLAND AND LOIHI. This map shows a 3D perspective of the bathymetry of the Big Island and Loihi. Loihi (lower center), is a submarine volcano located 17 miles off of the Big Island. It is destined to become the next Hawaiian island in 10,000 to 100,000 years, the most recent manifestation of the volcanic hotspot that has been responsible for the island chain formation. Loihi has been the site of numerous manned submersible and robotic dives to characterize its geology, geochemistry, and biology through an extensive program of sampling, mapping, and image documentation. (John Smith, Hawai'i Undersea Research Laboratory.)

LOIHI SUMMIT. Loihi is the site of earthquakes, landslides, and summit collapse as the active seamount continues its growth and evolution. These geological events could potentially trigger a tsunami. Loihi's summit is 3,000 feet below the ocean's surface; it changed drastically in 1996 when the summit collapsed, creating the pit craters shown. This was accompanied by 4,000 earthquakes; fortunately, these were small earthquakes over several weeks' time, and no tsunami was generated. (John Smith, Hawai'i Undersea Research Laboratory.)

PELE'S VENTS. The *Pisces V* submersible manipulator arm was used to collect a rock sample from Loihi. The white areas mark the sites of vents with bacterial mats surrounding them. Hot water, toxic chemicals, and the orange mineral nontronite effuse from the vents. This area no longer exists, as the summit collapsed in 1996. (Alexander Malahoff, Hawai'i Undersea Research Laboratory, provided by Rachel Orange.)

MOONSCAPE. The nontronite mineral chimneys on Loihi somewhat resemble the surface of the moon. Some vent areas on Loihi have been named the pits of death, so toxic that any animals swimming into the area die immediately due to lack of oxygen and presence of toxins in the water. A number of species new to science have been discovered on Loihi. (Alexander Malahoff, Hawai'i Undersea Research Laboratory, provided by Rachel Orange.)

Six

AN EVER-PRESENT THREAT

Hawai'i has experienced tsunami warnings and evacuations in 2010, 2011, and 2012. Fortunately, the tsunamis proved to be nonhazardous for Hawai'i, with the exception of the 2011 tsunami, when damage occurred on the Big Island's west (leeward) side. These tsunami events remind us of the ever-present threat for Hawai'i, since the islands can be hit from several directions.

In February 2010, a magnitude 8.8 earthquake shook Chile, triggering a tsunami that took at least 100 lives there. When the waves reached Hawai'i, they were smaller than expected, and there were no reports of property damage or injuries. Yet at magnitude 8.8, this was a large earthquake. The Chilean earthquake of 1960 triggered a damaging Pacific-wide tsunami, so why was the tsunami of 2010 so small? The answer lies in where rupture occurred. In 1960, the rupture extended well offshore, affecting more sea floor, and a vast amount of water moved. In 2010, rupture did not extend so far offshore and less water moved, hence a smaller tsunami.

In March 2011, the Japanese tsunami was generated by a 9.0 earthquake. Within an hour, a wall of water 30 feet and higher washed over the Japanese coast, with tremendous loss of life and property. People in Hawai'i prepared for its arrival here and watched in disbelief as they saw live coverage from Japan. Fortunately, the tsunami was nonhazardous (for Hilo). In Kailua-Kona, however, some businesses, homes, and infrastructure were heavily damaged.

In late October 2012, a 7.7-magnitude earthquake rattled the Queen Charlotte Islands in Western Canada. Warnings were issued for southern Alaska and western Canada, later expanded to include Hawai'i, where the effects were minimal.

What are the chances of another disastrous tsunami striking Hawai'i? On average, there is a hazardous tsunami in Hawai'i about every seven years. The last disastrous Pacific-wide tsunami was in 1960. It seems that the islands are overdue, but tsunami events cannot be predicted. We can only be assured that a disastrous tsunami will strike our shores again, most likely with adequate warning time that must be heeded.

PREPARED AND SPARED IN 2010. On February 27, 2010, a tsunami warning was issued in Hawai'i after deep ocean sensors detected that a tsunami had been generated after an earthquake in Chile, sending waves to Hawai'i. Hilo International Airport was closed so that area residents could evacuate via the facility's runways. Hilo Harbor and beach parks were closed. There was a concerted effort by civil defense, police, firemen, National Guard, Coast Guard, and volunteers to alert, mobilize, and protect the public from potential tsunami waves. Fortunately, the tsunami was smaller than expected, creating a 2.8-foot surge in Hilo Harbor. There were no reported injuries or property damage. The image at the Hilo Bay Lighthouse above shows a tsunami withdrawal (wave trough) at 11:30 a.m., followed by a tsunami surge (wave crest) at 11:43 a.m. below. The time interval between tsunami waves can vary from 15 to 40 minutes or more, and there are always multiple withdrawals and crests. (Both, Genevieve Cain Robison Collection.)

A Few Spectators in 2010. Most residents and shop owners took proper precautions with the warning of an incoming tsunami. Shops were boarded up, documents removed from premises, and people left tsunami-prone areas for higher ground inland. Nonetheless, there were a few foolhardy individuals (as shown above) who waited and watched on the Wailuku Bridge. A withdrawal occurred at 12:06 a.m. (above), followed by a surge at 12:51 p.m. (below). (Both, Genevieve Cain Robison Collection.)

A Sight to See at Sea. All manner and size of vessels—recreational, military, and commercial—created a spectacle as they set out from Honolulu harbors for the safety of deeper waters on the morning of March 11, 2011. The nautical rule is to clear the 100 fathoms (200 meter) line, where wave height is small and the wavelength is relatively long. The tsunami warning was taken seriously, and people generally followed civil defense instructions. (Terry O'Halloran Collection.)

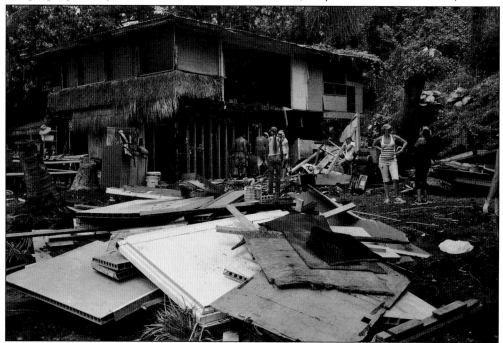

Keauhou Bay. The 2011 tsunami damaged homes, businesses, and infrastructure on the Kona side of the Big Island. The Sea Paradise Dive Shop is shown here. (NOAA/NGDC, Steve Dunleavy-SmugMug.)

2011 TSUNAMI IN KAILUA-KONA. The withdrawal (above) and surge (below) of tsunami waves that came from Japan in March 2011 can be seen in these photographs. The view is looking toward the pier and the King Kamehameha Kona Beach Resort. Note the damage to infrastructure. (Both, Brian and Linda Teahen Collection.)

ALI'I DRIVE IN KAILUA-KONA. There was significant damage to infrastructure, businesses, and homes on the leeward side of the Big Island as a result of the March 2011 tsunami. In December of that year, Hawai'i County Civil Defense estimated damage on the Kona side to be between $13 and $15 million. (Brian and Linda Teahen Collection.)

A RISING OF THE SEA. When a tsunami crest comes in, as shown here in Kailua-Kona in 2011, it is a rising of the sea, a powerful in-rushing flood of water. This view is toward the King Kamehameha Kona Beach Resort. (Brian and Linda Teahen Collection.)

TAKING PRECAUTIONS IN 2011. Shop owners wisely boarded up windows and doors to protect property. (Brian and Linda Teahen Collection.)

SHOPS AND HOMES DAMAGED. Some shops in Kailua-Kona were inundated with water, sand, and debris in 2011. There was inventory loss, broken windows, flooding, and some structural damage to businesses. There was also damage to homes, including one home that was wrenched off its foundation and was floating in Kealakekua Bay. (Brian and Linda Teahen Collection.)

LOBBY COVERED WITH SAND. The lobby in the King Kamehameha Kona Beach Resort was covered with sand after the 2011 tsunami. Note the doorframe and a treasure chest lying on the sand-covered carpet. (Brian and Linda Teahen Collection.)

BROKEN GLASS DOORS. The glass doors of the hotel were smashed when the tsunami waves came crashing in. Within a couple of weeks the damage was repaired, and the hotel was upgraded and reopened. (Brian and Linda Teahen collection.)

MUSEUM WITH A MISSION. The goals of the Pacific Tsunami Museum (PTM) are to prevent loss of life in tsunami events by promoting public tsunami education and to preserve the social and cultural history of Hawai'i. The museum also serves as a living memorial to those who lost their lives in past tsunamis. Cofounded by Dr. Walter Dudley and Jeanne Branch Johnston, PTM has an interesting history. In 1988, Dr. Dudley published the first edition of the book *Tsunami!* wherein he made a request of the community for survivor stories. In 1993, tsunami survivor Jeanne Branch Johnston saw the need for a tsunami museum in Hilo. A steering committee was formed. In 1997, First Hawaiian Bank donated its downtown Kamehameha Branch building as a permanent location for the museum. The building is a historical site, built in 1930 and designed by the late prominent architect C.W. Dickey. PTM opened its doors to the public in 1998. From that time to the present, the museum has expanded and enriched its exhibits to capture both the human stories and provide the scientific explanations of the tsunami events portrayed, in keeping with its mission. Many people in the community have devoted time and energy on the museum's behalf, beginning with those who transformed the original bank building into a museum and continuing today with the docents and others who contribute to PTM's visitor services and growth. (Author's collection.)

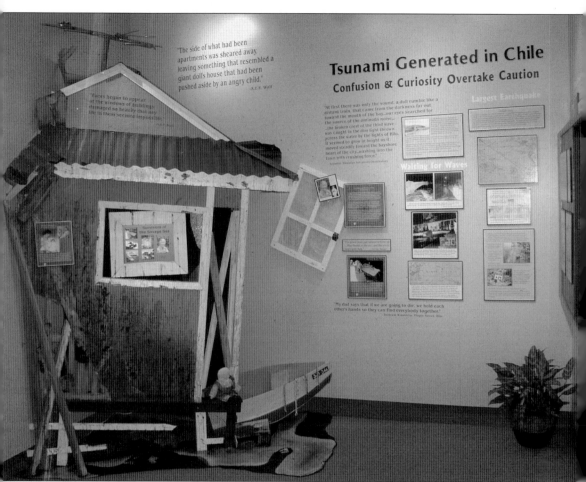

VISIT THE MUSEUM. The Pacific Tsunami Museum features exhibits that interpret tsunami phenomena through historical images, video kiosks, survivor stories, and interactive displays. There are exhibits depicting the impacts of the 1946, 1950s, and 1960 tsunami events in Hawai'i. There is also an exhibit that explains locally generated tsunamis, including the 1975 tsunami at Halape. The 2004 Indian Ocean tsunami and the 2011 Japan tsunami are featured in separate exhibits. A Science Room answers the questions of how and why tsunamis occur. The Tsunami Warning Center and wave machine exhibits provide hands-on experiences. Come visit the museum; there is so much to see and learn. Be prepared and be safe. (Jill Sommer Collection.)

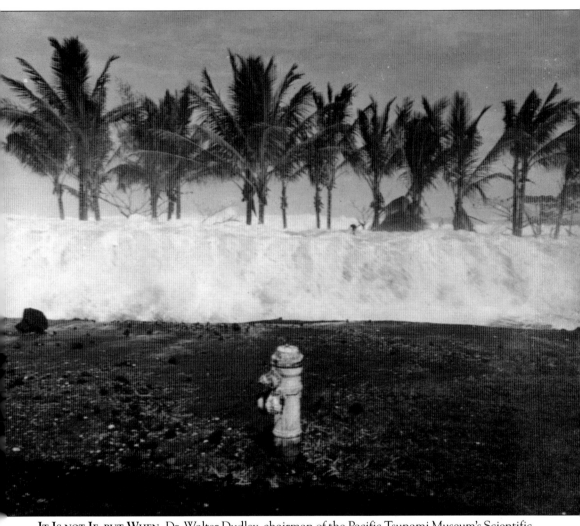

It Is not If, but When. Dr. Walter Dudley, chairman of the Pacific Tsunami Museum's Scientific Advisory Council, coauthored a book, *The Tsunami of 1946 and 1960 and the Devastation of Hilo Town* with Scott C.S. Stone and brilliantly wrote, "Since written records began in the early nineteenth century, at least a dozen tsunamis have roared onto the shore in Hawai'i killing 291 people, more than earthquakes, volcanic eruptions, and hurricanes together. Nothing has changed that would mitigate the awesome movement of land beneath or alongside the sea, or soften the impact of great waves born in the land's upheaval. The waves will come again as surely as the displacement of land will continue, and the waves will move across the Pacific at incredible speeds, sometimes with little or no warning, to crash onto the shore with unimaginable power." (Photograph by Charles Roderick Mason, Jeanne Branch Johnston Collection.)

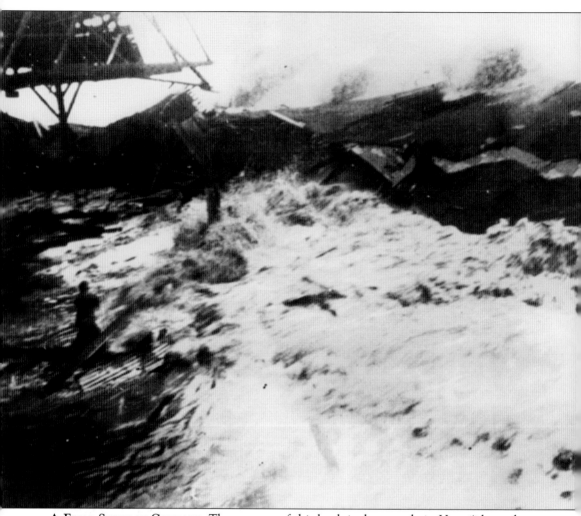

A FINAL STORY OF COURAGE. The message of this book is that people in Hawai'i have shown incredible courage and perseverance in the face of tremendous adversity, as past tsunamis have struck the islands. A notable story is that of Antone Aguiar (left), who worked for the railroad and was on Hilo Pier 1 the morning of April 1, 1946. The *Brigham Victory* was docked with a load of dynamite on board. After the first tsunami wave arrived, Antone and others ran for their lives, but Antone went back to turn off the pier's electricity and set the ship line free. With the lines free, first mate Edwin Eastman ordered the engines to start. A steward on board, Wayne Rasmussen, witnessed the scene with horror as he took this photograph that included Antone about to be engulfed. Thanks to the heroism of Antone Aguiar, the ship made it safely out to sea, and further disaster was averted. (NOAA/NGDC; photograph by Wayne Rasmussen.)

BIBLIOGRAPHY

Curtis, George D. "Tsunamis: Seismic Sea Waves." *Natural and Technological Disasters: Causes, Effects, and Preventive Measures.* Edited by S.K. Majumdar, G.S. Forbes, E.W. Miller, and R.F. Schmalz. 104–124. Philadelphia, PA: Pennsylvania Academy of Science, 1992.

Dudley, Walter C. *Tsunamis in Hawai'i.* Hilo, HI: Big Island Printers, 1999.

Dudley, Walter C. and Min Lee. *Tsunami!,* 2nd edition. Honolulu, HI: University of Hawai'i Press, 1998.

Dudley, Walter C. and Scott C.S. Stone. *The Tsunami of 1946 and 1960 and the Devastation of Hilo Town.* Virginia Beach, VA: The Donning Company, 2000.

Lang, Leslie. *Exploring Historic Hilo.* Honolulu, HI: Watermark Publishing, 2007.

Lynham, John, and Ilan Noy. *Forces of Nature and Cultural Responses.* Chapter 6: "Disaster in Paradise: A Preliminary Investigation of the Socioeconomic Aftermaths of Two Coastal Disasters in Hawaii." Edited by Katrin Pfeifer and Niki Pfeifer. 97–102. New York, NY: Springer, 2013.

Moore, James G., William R. Normark, and Robin T. Holcomb. "Giant Hawaiian Underwater Landslides." *Science,* New Series 264, no. 5155 (1994): 6–47.

"Project Kaiko'o." Final Report of the Hawai'i Redevelopment Agency.

Subica, Wayne A. *Hawai'i: Big Island's Moms and Pops Before Wal-Marts and K-Marts.* Hilo, HI: Memories of Hawai'i LLC, 2010.

Wall, A.E.P., ed. "The Big Wave: May 23, 1960." *Hilo Tribune-Herald.*

"The Wave: An account and review of the disastrous seismic wave which struck Hawai'i on April 1, 1946." *Hilo Tribune-Herald.* Compiled by Foreman Thompson.

DISCOVER THOUSANDS OF LOCAL HISTORY BOOKS FEATURING MILLIONS OF VINTAGE IMAGES

Arcadia Publishing, the leading local history publisher in the United States, is committed to making history accessible and meaningful through publishing books that celebrate and preserve the heritage of America's people and places.

Find more books like this at
www.arcadiapublishing.com

Search for your hometown history, your old stomping grounds, and even your favorite sports team.